LEARN TO PAINT WIT
ACRYLIC COLOURS
ALWYN CRAWSHAW FRSA

COLLINS
GLASGOW & LONDON

ALWYN CRAWSHAW

First published 1979
Collins Publishers, Glasgow and London

© Alwyn Crawshaw 1979

Designed and edited by Youé and Spooner Limited
Filmset by Tradespools Limited
Colour processing by Medway Reprographic Limited
Photography by Michael Petts

ISBN 0 00 411867 7

Printed in Great Britain

Rowney brushes and Cryla colours (both Standard and Flow Formula) were used for all the paintings illustrated in this book. Alwyn Crawshaw uses Cryla colours, mediums and varnishes for all his acrylic paintings and finds their consistency and permanence incomparable.

CONTENTS

PORTRAIT OF AN ARTIST
ALWYN CRAWSHAW *FRSA*

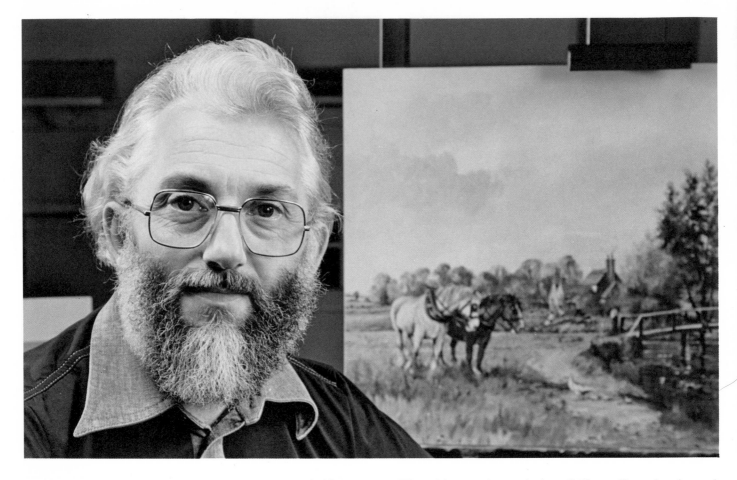

Alwyn Crawshaw was born in 1934 at Mirfield, Yorkshire; he now lives in Surrey. A painter, lecturer and author, his work has enabled him to become recognized as one of the leading authorities in the use of acrylic colours as a painting medium. During his earlier years he studied the many facets of both watercolour and oil painting, but since the introduction of the Cryla range of acrylic colours some fifteen years ago, Crawshaw admits to having now acquired a painting technique that, as he puts it: 'combines the best of both worlds'.

Crawshaw paints what he terms realistic subjects and these include many English landscape scenes which are frequently the subject of favourable articles and reviews by the critics. On numerous occasions these paintings have been compared with the works of John Constable, the best known of all the English landscape artists. In most of Crawshaw's landscapes there can be found a distinctive 'trade-mark' – usually elm trees or working horses.

The widespread popularity of Alwyn Crawshaw's work developed after the painting *Wet and Windy* (illustrated opposite, by kind permission of Felix Rosentiel's widow and son) had been included among the top ten prints chosen by the members of the Fine Art Trade Guild in 1975. Fine art prints of this well known painting are still very much in demand throughout the world. Another now famous painting was completed during Queen Elizabeth's Jubilee Year in 1977 when Crawshaw felt that he would like to record a particular aspect of the heritage of Britain symbolised by the celebrations of that year. After lengthy and painstaking research and hours spent working at the location, Crawshaw completed a large canvas, 51 × 153cm (20 × 60in), entitled *The Silver Jubilee Fleet Review 1977*. Part of this painting is illustrated opposite by kind permission of Mr C. Brannon, Hampshire. Crawshaw has been a guest on the *Jack de Manio Precisely* radio programme where he discussed his techniques when using

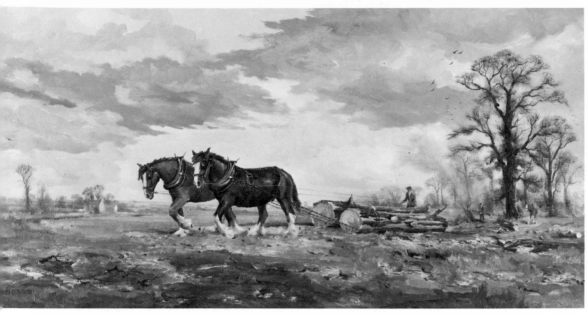

Success was assured for Crawshaw when his painting *Wet and Windy* was voted among the top ten prints chosen by the Fine Art Trade Guild in 1975. The print is now a bestseller

acrylic colours as a painting medium. He demonstrates these techniques to members of many art societies throughout the country.

Many of Crawshaw's paintings are dispersed throughout the world. They are sold in art galleries in the main centres of the United Kingdom, France, Germany, North and South America, Australia and Scandinavia. Some of his works have also been exhibited in Russia and in Eastern Europe, particularly Poland, Hungary and Romania.

Among some of the most important one-man exhibitions of Crawshaw's work are his three shows in the art gallery at Harrods, the famous department store in Knightsbridge, London. He has also held a one-man exhibition at Chester, which was opened by the Duchess of Westminster who now has a Crawshaw painting in her private collection.

One-man shows of his work frequently draw an enthusiastic audience, no doubt because his paintings are popular with both public and critics alike. There is a feeling of reality about them, an atmosphere which at times succeeds in transmitting to the onlooker a faint memory, as if one had been there before. Whatever it is, and no matter the season of the year, this feeling is usually experienced wherever Crawshaw's paintings are on view.

Alwyn Crawshaw is married and he and his wife have three children, two teenage daughters and a younger son. At weekends or holidays a sketching day will frequently turn into a family day out.

According to Alwyn Crawshaw, there are two attributes necessary for success as an artist: dedication and a sense of humour. The need for the first is self evident; the second 'helps you out of many a crisis'. In addition, Crawshaw acknowledges the unfailing loyalty of his wife and family.

The Silver Jubilee Fleet Review 1977

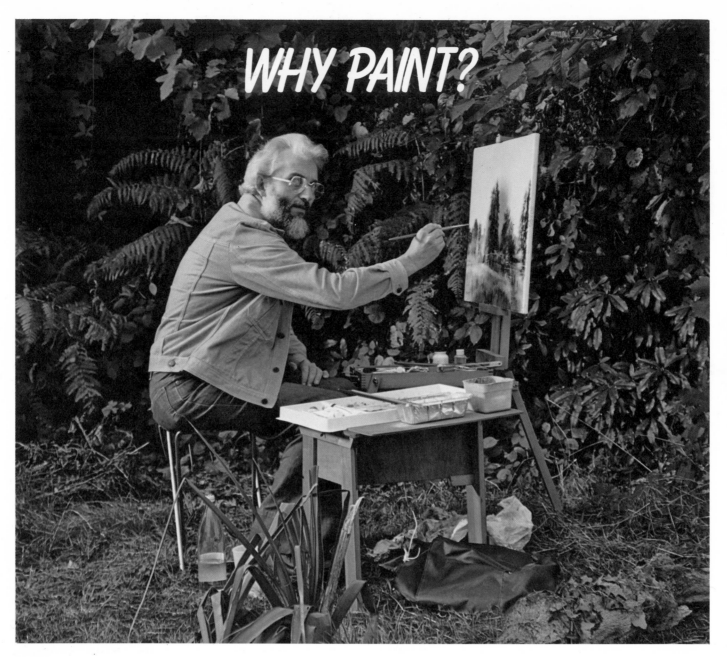

WHY PAINT?

Painting is one of man's earliest and most basic forms of expression. The Stone Age man drew on his cave walls. Usually, these drawings were of wild animals and hunting scenes. It is difficult to say whether these were created by the artist to be instructional – a means of showing his children what a certain animal looked like, for instance – or a form of cave decoration, or whether they were just a relaxing pastime to release his creative feelings. Whatever the reason, these artists must have been a very creative and dedicated people; there was no local art shop to provide them with their materials and no electric light to help on dark days. All this started over twenty-five thousand years ago and painting is still with us today.

Naturally, over this long, long period, painting has become very sophisticated. It has survived thousands of years of changing civilisations, styles, ideas and techniques.

Artist's materials have also undergone a vast change and the tremendous range now available, plus the variety of methods that are with us today, can make painting very frightening for the beginner: people can be put off by not knowing where or how to start. One of the most frequent statements made to me is: I wish I could paint. My reply is: Have you tried? and invariably the answer comes: Oh no, I haven't: I wouldn't know where or how to start. How can anyone say they cannot paint when they have never tried? Have you ever asked anyone if they can drive a car? If the answer is no, it will usually be followed by: I failed two tests and gave it up, or: I haven't tried yet but I am going to have lessons. The difference between painting and driving is simple: there seems to be a veil of mystery around painting but not around driving a car.

Let me clear your mind about some of the mysteries

Whether you like to paint out-of-doors or prefer a set piece (a still life) in your own studio, Alwyn Crawshaw will guide you step-by-step as you experiment with the best methods of using acrylic colour

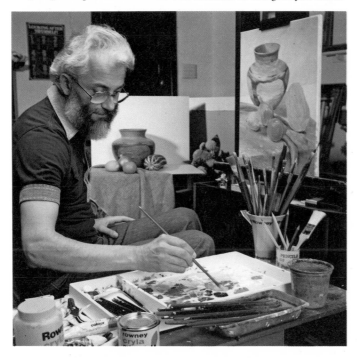

surrounding painting, from a beginner's point of view.

First of all, you may feel daunted by the sheer volume of work that has been created over the past thousands of years, the hundreds of styles and techniques used, from painting on ceilings to painting miniatures. Names may confuse you, such as: Prehistoric painting, Greek painting, Egyptian painting, Byzantine painting, Chinese painting, Gothic art, Florentine painting, Impressionism, Surrealism, Abstract art, Cubism, and so on. All these styles make the mind boggle and to unravel all of them and understand the differences could take a lifetime. So what are we to do and where do we start? The simplest answer is to forget all you have picked up in the past and start from the smallest beginnings like the Stone Age man.

Today, most people who want to paint have one thing in common – a creative instinct. Unfortunately, some of them don't realise this until later on in life, when something might stir within them or circumstances set them on the road to painting. For some people painting becomes a fascinating and relaxing hobby. For others it becomes their only way of expressing their innermost thoughts and leads to a means of communicating with other people. For anyone who happens to be house-bound, painting can have a real therapeutic function; through painting, people meet and make friends either by joining art societies (most towns have one) or by progressing and selling their works at local art shows, in local shops and so on. I think, above all, painting can be a creative way of getting involved, forgetting all your immediate troubles, great or small, and finishing up with a work of art that you can share with others and enjoy for the rest of your life.

By now, as the reader of this book, you have taken your first big step: if you are a beginner, this means that you are curious about painting and want to find out all about it. You have also selected a medium with which to start: acrylic colour. If you already paint and are reading this book to learn about acrylics as another medium, then probably your curiosity and creative instincts are looking for other exciting ways to express your pictorial skills.

Now, as I said a little earlier, let's start right at the beginning. Don't rush out to find the nearest cave! I will take you through this book stage by stage, working very simply to start with and progressing to a more mature form of painting. If you have some acrylic colours, the most difficult thing to do at the moment will be to read on – your desire to try out the paint will have been stimulated by looking through the book and seeing the colour pages and different methods of working. If this is the case, you are well on your way but do one thing first: relax and read on before you start. When you do start the lessons and exercises – enjoy them. If you find some parts difficult, don't become obsessed with the problem; go a stage further and then come back. Seeing the problem with a fresh eye will make it easier to solve.

WHY USE ACRYLIC COLOURS... AND WHAT ARE THEY?

Why use acrylic colours? I am constantly asked this question. The quick answer is that I *like* using them and they suit my personality. I will explain that in more detail and then finish this chapter with a brief technical description of this medium. Acrylic colours first arrived on the market in this country in 1962, in a form called Standard Formula. As you can see from the photograph above, this formula, in the smaller tube, is very thick and has a buttery consistency similar to oil colour. Because of its consistency it was used mainly for palette knife work. The painting could be built up to achieve a tremendous amount of relief work (impasto). The immediate advantage of acrylic over oil colours used in this way was that oils would take months

to dry but acrylics would take only hours, even when put on really thickly. Besides artists working with palette knives, there were also artists like myself using brushes with this new medium.

Then, along came the ultimate for the brush man – Standard Formula's stable mate, Flow Formula. Look again at the illustration above and you can see the difference in consistency. Flow Formula, in the large tube, flows; it is better to use with the brush and takes a little longer to dry than Standard Formula. Since then, there has come on to the market a retarder one can add to the paint to slow down the drying time; and a paste called Texture Paste for building up heavy impasto. There are also high-quality nylon

Fig. 1

See the results given by the various kinds of acrylic colour: at the top the colour is mixed with Texture Paste for maximum relief. Below, Standard Formula colour is liberally applied. Stage three shows Flow Formula colour painted flat and stage four shows how a watercolour technique can be achieved

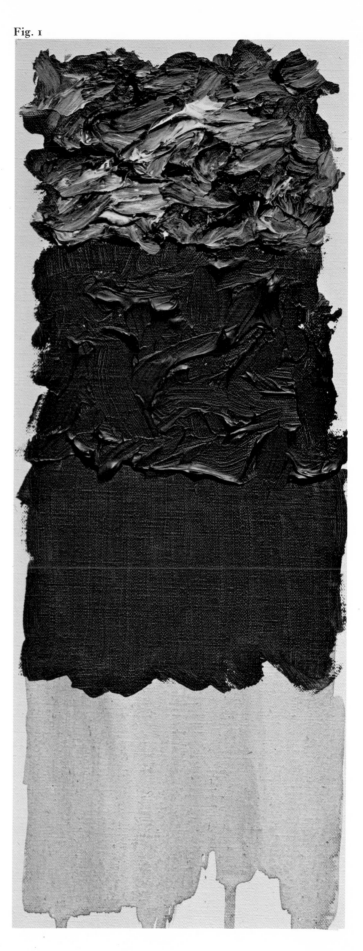

brushes, which I use all the time and find best for acrylic painting, apart from small detail work. More recently, a Staywet palette, which keeps the paint wet on the palette almost indefinitely, was introduced and proved a tremendous breakthrough since it saves a lot of paint that was once wasted through drying too soon.

Why do acrylic colours suit my personality? I believe that a painting comes from the inner self, this gives it the mood – the atmosphere – the invisible quality that makes a painting look alive. If we make a ridiculous assumption and say you have a tremendous urge to paint a particular landscape from one of your sketches and you could paint it in three minutes while that urge was there, then that painting would express your true, uninterrupted feelings on the canvas. Now, three minutes to paint a picture is ridiculous. However, because acrylic colours dry so quickly, a certain speed is possible. As one stage of the painting is done, you can overpaint immediately without picking up the paint from underneath; consequently, you can keep working while the inspiration is there. If circumstances permit, you can start a painting in the morning and finish it in the afternoon as each stage will be dry enough for you to follow on with the next. If you like to put detail in a picture, you can do so as and when you feel it necessary, because the paint will dry quickly enough to allow you to work on top of the previous layer. Being able to paint in this manner is the nearest thing to being able to maintain that feeling for the painting. Even if the whole picture can't be finished at one sitting (which is usually the case), at least certain passages can be worked up to your requirements without being dictated by the long drying time of the paint. It is a direct way of painting and this is one of the reasons why it suits me. You can decide what you want to paint, then go ahead – and you can keep going.

Naturally, as with all painting whether it be oil, gouache, watercolour or whatever, there are techniques to be learned and certain disciplines to be acquired before you can master the medium. These techniques are described later in the book; by that time, if you have been a good student and have not skipped a few pages, you will have learned quite a lot about the handling of the paint. An interesting exercise is illustrated in **fig. 1** to show the versatility of acrylic colours. Starting from the bottom, we have a canvas, then a delicate watercolour treatment, followed by Flow Formula painted flat, then plenty of Standard Formula giving texture to the surface, and finally acrylic colour added to Texture Paste to get the ultimate in relief work.

We will now look at the basic working methods. The colours come in tubes; always remember to put the cap back on or the colour will start to dry in the tube. You mix

Fig. 2

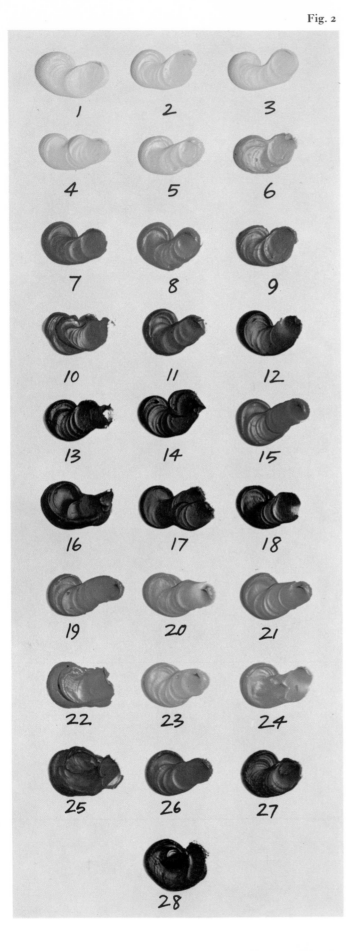

the colour with water – not white spirit or turpentine – and wash your brushes out in water; there is no smell given off when using acrylic colours.

It is advisable to keep your nylon brushes in water all the time – twenty-four hours a day. I have brushes that have lived in water now for seven years. No harm has come to them and since I have been using this method, none has gone hard because of paint drying on it. If by accident you let a brush get hard, soak it overnight in methylated spirit, then work it between the fingers and wash it out in soap and water. When you finish using a brush, even if you know you will need it again in a few minutes, *put it back* in your brush dish; make this one of your first disciplines. When you take it out of the brush dish to use it again, dry it out well on rag. Keep some clean rag handy at all times for this purpose. Only use a *damp brush* when working normally as the acrylic's own consistency is all you need. If you use sable brushes, however, never leave them in water – wash them out immediately after use.

When you squeeze your paint out on to the palette, *always* put the colours in the same *position*; this is another important discipline. The reason is simple: the way you pick up colours from your palette must become second nature as you will have enough to worry about without searching for a particular colour. You will see that in **fig. 3** I have laid out the colours I use in the order I have them

1. Primrose
2. Cadmium Yellow Pale
3. Lemon Yellow
4. Permanent Yellow
5. Cadmium Yellow Deep
6. Cadmium Orange
7. Vermilion (Hue)
8. Cadmium Scarlet
9. Cadmium Red Deep
10. Permanent Rose
11. Red Violet
12. Deep Violet
13. Permanent Violet
14. Indanthrene Blue
15. Cobalt Blue
16. Monestial Blue
17. Monestial Green
18. Hooker's Green
19. Opaque Oxide of Chromium
20. Pale Olive Green
21. Rowney Emerald
22. Turquoise
23. Yellow Ochre
24. Golden Ochre
25. Burnt Sienna
26. Venetian Red
27. Transparent Brown
28. Black

on my palette. There is no magic about the way these are placed, I started this way at art school and I have stuck with it ever since. Because this colour layout works well I suggest you adopt it. I use these ten colours normally but illustrated on the left, in **fig. 2**, is the range of additional colours that you can get in both Flow and Standard Formula.

If you are *not* using a Staywet palette, then use either a glass or plastic surface, or even a dinner plate upon which to mix your colours. Remember that the paint will start to dry while you are working. Do not put out more paint than you will be able to use at one sitting *unless you are using a Staywet palette.*

I think that's enough to absorb for the time being but, for the technically minded, here is the make-up of acrylics. Artists' acrylic colours are made with the same organic and natural pigments used in the manufacture of oil colours. Instead of being bound in a drying oil as in the case of oil colours, or a water-soluble gum as in the case of water-colours, these semi-permanent pigments are bound and dispersed in a transparent, water emulsion of acrylic polymer resin.

Acrylic polymer resins are the product of modern chemistry and are familiar to most people in the form of transparent plastics such as Perspex. The term polymer means the joining together of small molecules, called mono-mers, into long chemical chains forming plastic materials.

These resins are converted into milky white, water emul-sions which will dry as a crystal clear film once the water has evaporated. These emulsions are versatile adhesives in their own right. Combine these resin emulsions with permanent, artists' quality pigments and you have the near ideal situation of a permanent-pigment particle encased in an inert, transparent coating which is not subject to deterio-ration, yellowing or embrittlement.

Acrylic colours allow a versatility of technique far greater than that of any other medium. The use of additional mediums is covered in the section Basic Techniques. The films of paint formed are tough and flexible and not subject to yellowing. Acrylic paintings can be cleaned by gentle sponging with soap and water.

Acrylic colour is today's modern, instant, permanent and multi-purpose, artists' medium.

Fig. 3

A COERULEUM BLUE

B BRIGHT GREEN

C BURNT UMBER

D RAW UMBER

E CADMIUM YELLOW

F CADMIUM RED

G CRIMSON

H ULTRAMARINE BLUE

I RAW SIENNA

J WHITE

MIXING AREA

WHAT EQUIPMENT DO YOU NEED?

Equipment can vary from the basic essentials to a roomful of easels, boards, canvases, a wealth of brushes and so on. Some people collect brushes like some anglers collect fishing floats. There's nothing wrong in this at all – in fact, I tend to collect brushes; I have far more than I will ever use but I enjoy the feeling that somewhere I have a brush for the job. Anything beyond the basic equipment, I think, must be left to the individual. I will now guide you through the list of basic essentials, bearing in mind that I will recap at the end of this section.

On the facing page is a photograph of my working table in my studio. It is slightly overcrowded intentionally, so as to show art materials in a working environment and to illustrate how to set up your equipment: the key is below.

Having discussed acrylics earlier, we will now consider the brushes you will need. These are the tools of the trade, they are the instruments with which you will create shapes and forms on your canvas and are by far the most important working equipment you will ever buy. I am asked time and time again: What brushes do I need? My answer always is: The best quality; remember, it is the brush that allows your skills to be expressed and seen. Never treat a brush as a show piece when you are working with it. The brush has to perform different movements and accomplish many different shapes and patterns. If it means that you have to push the brush against the flow of the bristles – then do it. This way, your brushes will gradually become adaptable for certain types of work; you will get to know them and thus

A CANVAS
B EASEL
C WOODEN LAY FIGURE
D WATER CONTAINER
E BRUSH TRAY
F BRUSHES & BRUSH HOLDER
G PENCILS
H VARNISH BRUSH
I TEXTURE PASTE/VARNISH
J PRIMER
K PALETTE KNIVES
L ERASERS
M MEDIUM NO.1 – GLOSS
 MEDIUM NO.2 – MATT
 WATER TENSION BREAKER
N GEL RETARDER
 MEDIUM NO.3 – GLAZE
O FLOW FORMULA COLOURS
P STANDARD FORMULA COLOURS
Q PAINT RAG
R DRAWING BOARD & PAPER
S STAYWET PALETTE
T SABLE BRUSHES

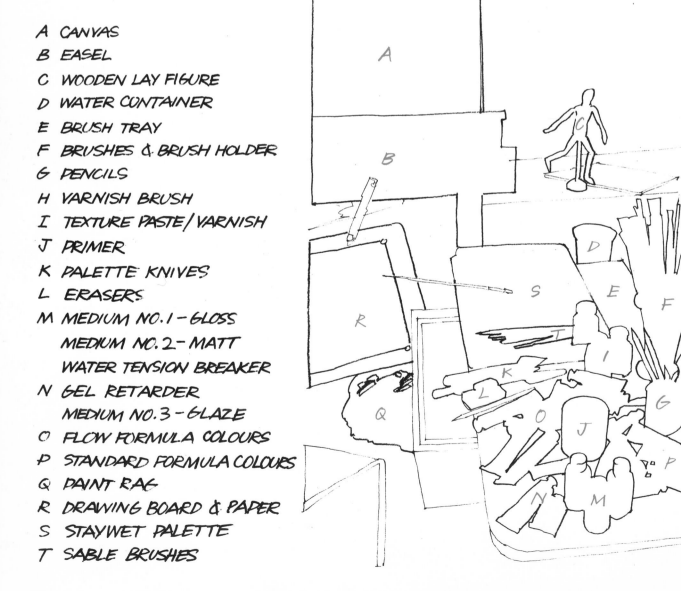

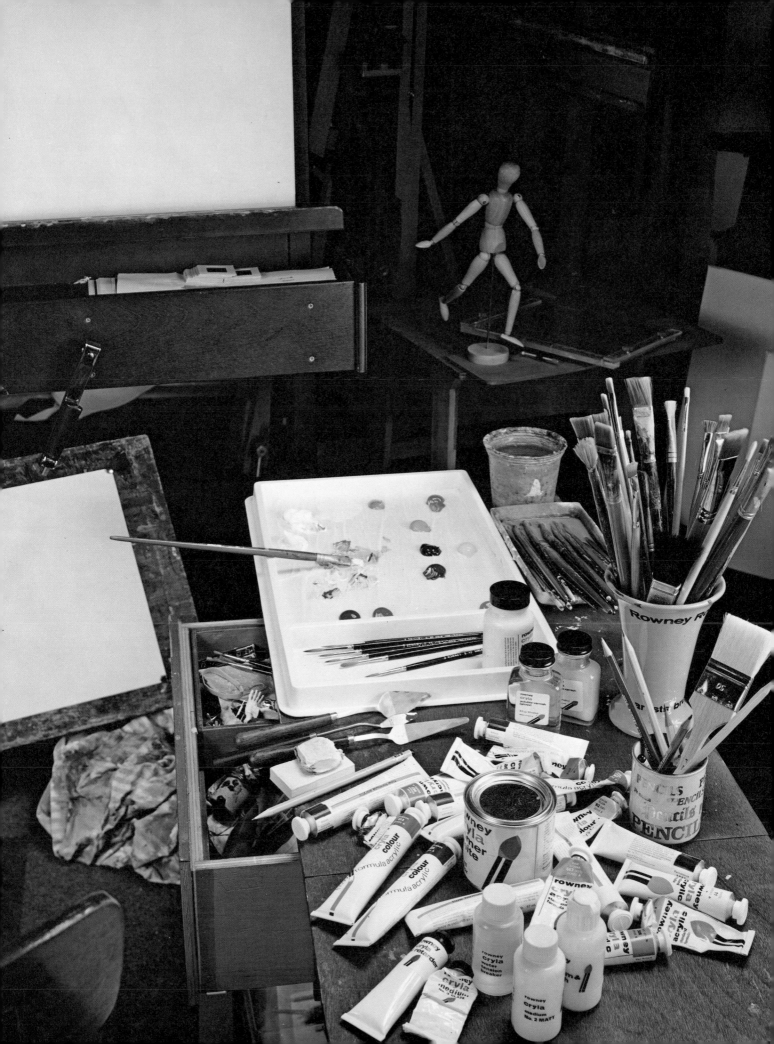

will be able to get the best out of your painting. As one says of the colours on the palette, know your palette, so one should say, know your brushes.

Illustrated here are three different series of nylon brushes and two watercolour series which I use. The Series 201 nylon brush holds less paint than the Series 220 and it is this brush that I use the most. I use Series 260 in place of sable brushes when I want to be more rough with them. As for sable brushes, I use sizes Nos. 1, 2 and 3 of Series 56 for fine line work, and sizes Nos. 3, 4 and 5 of Series 43 for larger, delicate work.

Some artists prefer to use a palette knife instead of a brush. But don't be too rough with the palette knife or you will put a knick in it or catch it in the canvas and flick paint everywhere. Three knives are illustrated and these could be used as a set to start with.

I have already mentioned palettes and a Staywet palette is illustrated on page 13. This is also the best palette for painting out-of-doors. You will also need the materials upon which to apply the paint. Canvas, wood, cartridge paper, brown paper, all these can be used as surfaces for acrylic painting. When we start on our first lessons we will be using some of these surfaces. You will need a drawing board upon which to rest your paper, to give you a firm support while painting.

Three easels are illustrated. Easels are not essential for small work if you are working on paper pinned to a drawing board, but the small table easel is ideal if you want your board at an angle on the table. The large, radial, studio easel is essential for large work as the support you are using must be held firm. The last easel illustrated is a portable one for use out-of-doors; it also folds down and turns into a carrying box for your paints and a canvas up to 69cm (27in) deep. It can also be used inside as your permanent one.

Series 201 brushes hold less paint and are commonly used

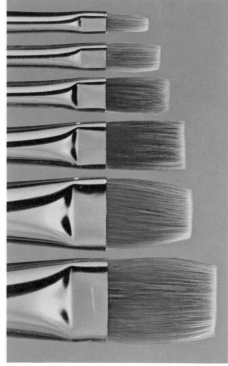

This is Series 220

Series 260 brushes are often used in place of sable brushes as they stand up to tougher treatment

Series 56 sable brushes are used for fine line work

Series 43 sable brushes are used for larger, delicate work

The tray in which I keep my brushes is an old ice box from the fridge; it is long and flat and has been the permanent home for my brushes for the past seven years. When I go about demonstrating I use a tin-foil container, which is just as efficient. Finally, there are special containers on the market for holding brushes in water.

Gel Retarder is very useful to have as it is used for large areas of painting wet on wet. We will come to this in the section Basic Techniques. You will need some acrylic primer for surfaces that are porous and Texture Paste for the Basic Techniques exercises. You will need a water jar for washing out your brushes; this can be anything from a jam jar to a Ming vase. Finally, you need HB and 2B pencils and an eraser.

And so, your basic equipment list will be as follows: a set of ten acrylic Flow Formula colours – colours as on p. 11; brushes, Flat 'curved-in' Nylon size No. 2, Flat Nylon sizes Nos. 4, 8, 12, Round Poster Writing size No. 1, Long hair Sable – Designers Brush size No. 5; Staywet palette, drawing board, brown paper, white cartridge paper, brush tray, acrylic primer, water jar, HB and 2B pencils, and an eraser. This basic equipment will see you through the first exercises and, as you gain more confidence, you can add to your range.

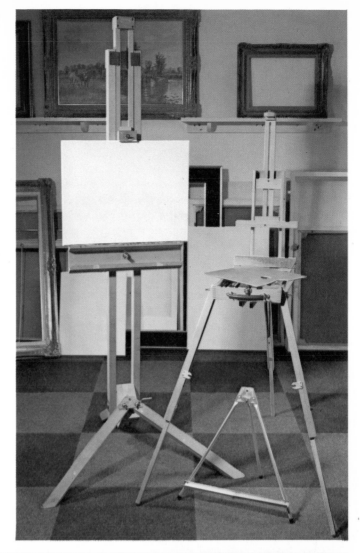

Below is a range of palette knives suitable to start painting: be careful how you use them! On the right are the three most useful easels: a small table type, a large radial studio easel, and a portable, folding one which converts to a carrying box for paints and canvas

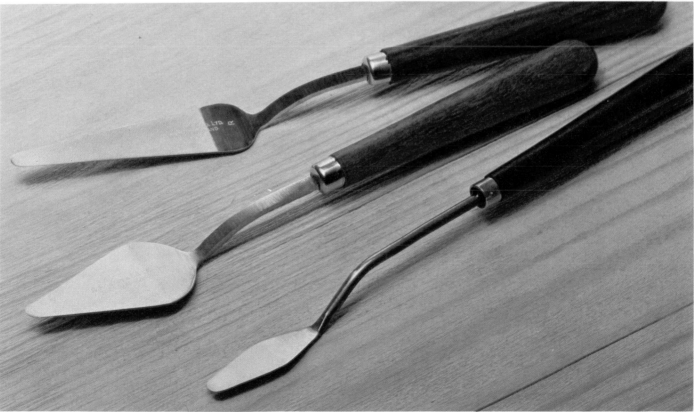

LET'S START PAINTING

PLAYING WITH PAINT

Now you can start painting. A lot of people who have not painted before find this the most difficult bridge to cross – to actually put some paint on paper. Unfortunately, we are all self-conscious when it comes to things we have never tried before and our families don't help either! I have often come across the case of a member of the family who sees someone's first efforts at painting: remarks such as, What's that! and, Oh well, never mind, are never meant to hurt or be unkind but unfortunately, they can upset and put off a sensitive beginner – sometimes for good. Well, here is the way we will get over that problem if it arises. It's part of our human nature to strive to do better and if we try to run before we can walk, then this is when disaster will strike and cause those humorous comments from the family. So we will start at the very beginning and take things in a steady, progressive order – I'll see you don't run first.

Let us take colours as our first step into painting. The hundreds of colours that exist all around us might present an overwhelming proposition for a beginner. But this can be simplified: there are only three basic colours, *red*, *yellow* and *blue*, which are called primary colours (see **fig. 4** on the right), and all other colours, and shades of colour, are formed by a combination of these three. In painting there are different reds, yellows and blues which we can use to help recreate nature's colours. Look at **fig. 4** again and you will see there are two of each primary colour and a further three colours and white to make mixing easier. As I have illustrated earlier, these colours are the ones I use for all my acrylic painting.

Before you start mixing colours, get yourself a piece of

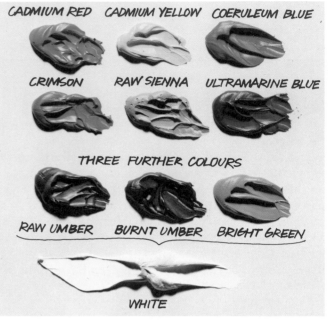

Fig. 4

brown paper and play with the paint on it. See what it feels like, use your fingers if you like, try a brush, a palette knife, anything you like; add more water, less water, mix colours together. You will end up with a funny-looking, coloured piece of brown paper. Incidentally, if the family laugh at this one, laugh with them; show them my doodles on brown paper (**fig. 5**) and laugh at that! What you have done is to experience the feel of acrylic colour. It isn't a stranger any more, nor are your brushes. You have now broken the ice and will feel much more confident in tackling the next stage. Good luck.

Fig. 5

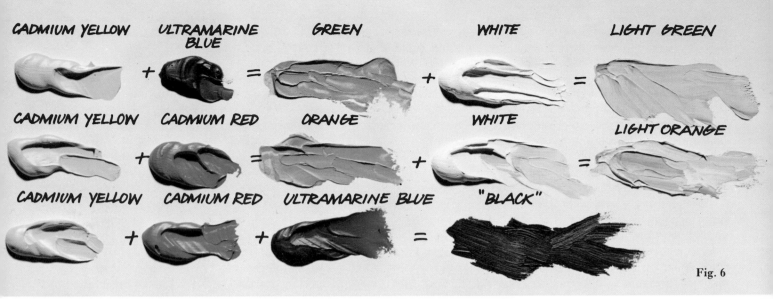

CADMIUM YELLOW + ULTRAMARINE BLUE = GREEN + WHITE = LIGHT GREEN

CADMIUM YELLOW + CADMIUM RED = ORANGE + WHITE = LIGHT ORANGE

CADMIUM YELLOW + CADMIUM RED + ULTRAMARINE BLUE = "BLACK"

Fig. 6

MIXING COLOURS

As we progress through the exercises I will help you as much as I can, but first you must spend some time practising mixing different colours. In **fig. 6**, I have taken the primary colours and mixed them to show you the results. In the first row, Cadmium Yellow mixed with Ultramarine makes green. If you then add White, you finish up with a light green. In the second row, Cadmium Yellow is mixed with Cadmium Red and this makes orange. To make orange look more yellow, add more yellow than red and to make it more red, add more red than yellow. Add White to make the orange paler.

You may have noticed that my palette does not include black. Some artists use black and others don't. I am one of the don'ts. I don't use black because I believe it is a dead colour . . . too flat; therefore, I mix my blacks from the primary colours. It can be difficult for beginners to get really dark colours at first and if you get frustrated, then I don't mind your trying black, but use it very sparingly and see how you get on with it. Remember that in general, if you want a colour to be cooler, add blue and if it is to be warmer, then add red.

Using white cartridge paper, practise mixing different colours. Mix these on your palette with a brush and paint daubs on to your white paper; don't worry about shapes, it's the colours you are trying for. Experiment and practice are the only real guidelines I can give you here. Next time you're sitting down watching television, look around you: pick a colour and try to imagine what other colours you would mix to obtain it.

One last important thing: when there are only three basic colours, it is the *amount* of each colour that plays the biggest part. You can easily mix a green as in the first line in **fig. 6** but if it is to be a yellowy green, then you have to experiment on your palette; you have to mix and work in more yellow until you have the colour you want. This lesson of mixing colours is the one you will be practising and improving upon all your life – I am, still.

PAINTING WITHIN GIVEN SHAPES

Now the time has come to learn to control the paint brush. As usual, when you know how, it is much easier than you thought. A lot of control has to be exercised when painting edges of areas that have to be filled in with paint, like the circle in **fig. 7**. Take a two-pence piece or something similar and draw round it with an HB pencil. You can do this on cartridge paper or brown paper. Use your small sable brush with plenty of water. Remember, with nylon brushes you should just dampen the bristles but with sable brushes you need water mixed with the paint to allow the latter to run out of the brush. Try it now, before you start filling in your circle, and get used to the right mix.

When filling in the circle, start at the top and work down the left side to the bottom. Let the bristles follow the brush, i.e. pull the brush down. Try to do this in two or three

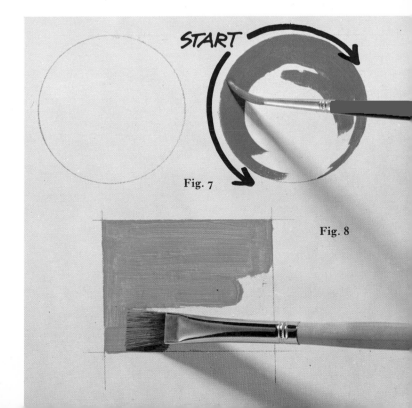

START

Fig. 7

Fig. 8

movements. While painting the left side you will notice that you can follow the pencil line but as you start at the top again and paint the right-hand side, your brush will cover some of the pencil line and you will feel slightly awkward. You may have found the answer already: turn the paper round and paint the second half like the first! Well, full marks for initiative, but there is a problem – what happens if you are painting a very large canvas or a mural? You can't turn *that* round to suit your brush strokes. The answer is to accept that it feels a bit awkward but the more you practise the more natural it will feel.

Now let's go on to straight lines. This time, have a go at drawing a square, like the side of a box. Try this one free-hand, don't draw around anything. Here is a *very important* rule to remember: when you are drawing straight lines (unless you are drawing very short ones) always move your wrist and arm, not your fingers. Try this with a pencil: first draw a straight line downwards moving only your fingers. You will find you can only draw a few centimetres before your fingers make the line bend. Now do the same exercise with your fingers firm: move only your hand, bending the arm at the elbow, and it will not wobble. You can paint the edges of the box with a small sable brush again or use a small, flat, nylon brush as in **fig. 8**. Experiment with this flat brush, trying out various ways of holding it. You can then use this same brush for filling in the square.

Now draw your own shapes and fill them in, and (to keep you at it) mix your own colours. Look around, choose a colour, perhaps that of your shoes, or wallpaper; try to mix a colour like it and use this paint for painting in your shapes. You are doing all you have learned so far in this one exercise: well done – but keep at it, enjoy it and practise.

ELEMENTARY PERSPECTIVE AND DRAWING

Drawing or the knowledge of drawing comes before painting and therefore, we will take a little time to practise simple perspective. If you believe you can't draw, don't let this worry you. Some artists can paint a picture but would have difficulty in drawing it as a drawing in its own right. It is the shapes of the masses, the colours and tones that make a painting. If you are capable of drawing in detail, then that is fine but it is not necessary to be a *perfect* draughtsman to be able to paint pictures. Throughout the centuries, artists have looked for and invented drawing aids. Today, there is a very simple but very effective aid to drawing on the market called a *Perspectograph* – it sorts out the perspective for you. Even to those who have not drawn before, words such as horizon, eye level and vanishing point are not unfamiliar. Let us see how we use them.

When he looks out to sea, the horizon will always be at the artist's eye level, even if he climbs a cliff or lies flat on the sand. So the horizon becomes the eye level (E.L.). If you are in a room, naturally, there is no horizon but you still have an eye level. To find this, hold your pencil horizontally in front of your eyes at arm's length; where the pencil hits the opposite wall is your eye level. If two parallel lines were marked on the ground and extended to the horizon, they would come together at what is called the vanishing point. This is why railway lines appear to get closer together and finally meet in the distance – they have met at the vanishing point (V.P.).

First, look at **fig. 9**: I have taken our box, the square you drew in the previous lesson, and put it on paper. Then I

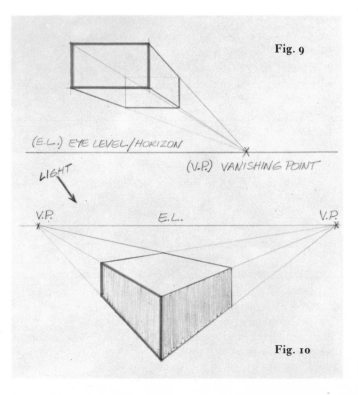

Fig. 9

(E.L.) EYE LEVEL/HORIZON

(V.P.) VANISHING POINT

LIGHT

V.P.　　　　　　　E.L.　　　　　　　V.P.

Fig. 10

Fig. 11

drew a line underneath, representing the eye level. Then, to the right-hand end of the E.L., I made a mark, the V.P. With a ruler I drew four lines from the corners of the box, all converging at the V.P. This gave me the two sides, the bottom and the top of the box. The effect is that of a transparent box drawn in perspective. Incidentally, we are looking up at this box as the eye level is low.

Look at **fig 10**: I have put the E.L. high so as to look down on the box. Also, the box is at an angle which gives us two vanishing points, one for each side of the box. I have shaded in the box with pencil to show the light direction. Draw this box with your HB pencil on paper and colour it in as you did in the previous exercise.

Look at **fig. 11** and you will see the method of painting the surfaces of the box. First, paint all the sides of the box in Bright Green; then the two sides with Bright Green and Burnt Umber; finally, the darkest, shadowed side with Bright Green and Burnt Umber, adding a little Ultramarine. You have now completed a simple exercise but it is the *most important exercise* you will ever do. You have created, on a flat surface, the illusion of depth, dimension and perspective; i.e., a three-dimensional object.

When you painted the box in the first stage, did you notice that although the box was drawn in perspective, it looked flat – a silhouette? This was because there was no light or shade (light against dark). It is this light against dark that enables us to see objects and understand their form. If we were to paint our box blue on the same blue background and there was no light or shade (light against dark) it would look like **fig. 12**. If light and shade were added, it would look like **fig. 13**. You must always be conscious of light against dark whenever you are painting.

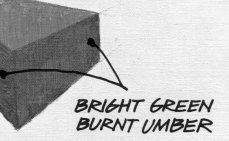

BRIGHT GREEN

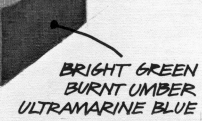

*BRIGHT GREEN
BURNT UMBER*

*BRIGHT GREEN
BURNT UMBER
ULTRAMARINE BLUE*

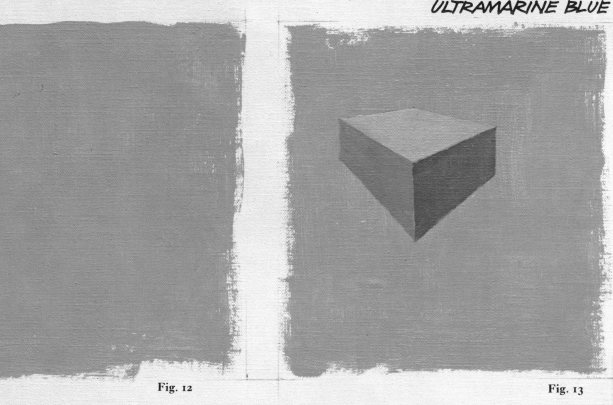

Fig. 12

Fig. 13

When you are painting, it will help you with shapes if you look at the scene through half-closed eyes. The lights and darks are exaggerated and the middle tones tend to disappear: this gives you simple, contrasting shapes to follow. I made the point earlier that you do not have to be a perfect draughtsman to be able to paint, and if you want to enjoy painting, then you must not let this put you off. If you go round an exhibition by a number of artists, you will see a tremendous range of different types of painting. Some are very detailed, some are almost flat areas of colour.

Next time you are in the country, look at a scene and half close your eyes: you will see definite shapes that you can easily draw, you will see the light areas against the dark ones and you will find that painting that particular scene is much easier than you had thought. Look at **fig. 14**: I have done a pencil drawing of a landscape. In **fig. 15**, I have simplified it considerably when I painted it. This is what you have to aim for at this stage.

Fig. 14

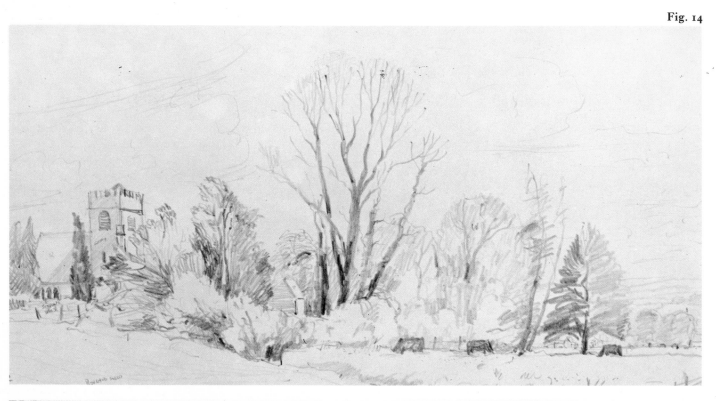

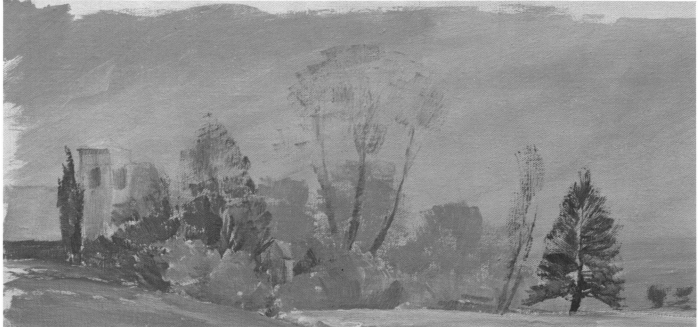

Fig. 15

20

SIMPLE OBJECT PAINTING

We are now ready to paint some simple and familiar objects. If you have practised with your colour mixing and drawing, you will not have much difficulty in copying what I have drawn or in finding your own objects to paint from life.

The best way to start is to copy my illustrations. This will save your worrying about the drawing problems inherent in copying a real object. However, when you have copied from the book, then get the object, set it up in front of you and have a go from the real thing. You will thus feel more familiar with the object itself, having painted it first from the book.

These simple objects must be treated in the broad sense without worrying about detail. Remember: when painting from the real thing, half close your eyes to see the forms and light and dark areas which simplify the shapes where the object is too complicated. Try to paint direct, in these exercises; in other words, go for the colour you see and try to get it first time on to the paper. These exercises are not meant to try your skill at details but to give you experience in painting a whole picture, observing shapes and tones, and applying what you see to paper. In this lesson we will use different supports (surfaces) on which to paint. Let's use cartridge paper first.

Our first simple object is a brick; I am sure you can find one somewhere. Paint the brick in the same way as the box but this time, try to paint each side separately with its own colour (the background was painted beforehand), i.e. the top of the brick was painted first, using the colours shown in **fig. 16**, then the light side and finally, the very light side. The recess in the top of the brick was done last by adding shadow to its left-hand side (**fig. 17**).

We will now use newspaper. On page 22 is a newspaper with a banana painted directly on to it. The banana was

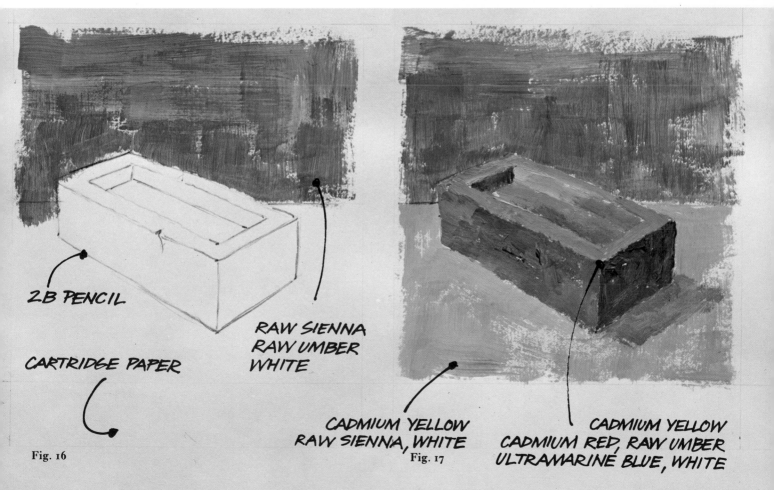

2B PENCIL

CARTRIDGE PAPER

RAW SIENNA
RAW UMBER
WHITE

Fig. 16

CADMIUM YELLOW
RAW SIENNA, WHITE

Fig. 17

CADMIUM YELLOW
CADMIUM RED, RAW UMBER
ULTRAMARINE BLUE, WHITE

A STRUGGLE TO DRAW

LGO benefit n transfusion

Matched teams in melee

Field still out of luck

TABLE TENNIS

Cook getting the other two for Mouchel.

In Division Two the BAe teams started well. The D 7.3 with their A. Mouchel B 6-4 with the latter match easier for John Hodkinson had some in a comeback by John Sterfield.

Newcomers had got to a good fashion Club B. led by John won all g. Mike for 77 en match wed drew Brian

Newly promoted Post Office A carried on in Division Three where they left off last season with a 10-0 win over New Haw A, who had ex Division One player Alan Hughes in their tanks.

In Division Four Post Office B were defeated 8-2 by Old Woking C. BAe D beat Byfleet LTC F 7-3. Dave Thomas winning a1 three. However, BAe E went down 6-4 to Birdseye whose number one, Ian Hunt, won all his games.

Newcomers CUACO drew with Bottles B, their top player, M. Derbyshire, winning his three singles. In the same section BAe F won 9-1 over Mouchel D and Hersham B beat Airscrew D 8-2. Both Division Six results were 6-4 wins. New Haw B beat Broadoaks C and BAe G beat ... LTCH.

Division One: Nalgo A 9. 77 ..., b 4, Byfleet LTC A 5. Mouchel A 5.

Division Two: BAe B 6. Mouchel B 4. BAe A 2. 77 D 3; Old Woking B 3. Premier A 2.

Division Three: Post Office A 10. New Haw A 0.

Division Four: Byfleet LTC F 3. BAe D 7; Old Woking C 8. Post Office B 2.

Division Five: Airscrew D 2. Hersham B 8. Mouchel D 1; BAe F 9. CUACO 5. Botleys B 5.

Division Six: New Haw B 6. Broadoaks C 4; BAe G 6. Byfleet LTC H 4.

and Gordon Aplin all scored one each.

CKETERS NDOORS

Esher were the victors run, 66 to 65.

Woking and Horsell fini on the wrong side of BAe again by the odd run and with an identical score, 66 to 65.

After a bad start, Avonans thrashed Westfield 108 to 53. Keith Bedford pulled them together with a fine knock of 46 after they had lost their first three wickets for 20 runs.

Byfleet beat Old Hamptonians 86 to 83 in another well contested game.

Cards loose grip

WOKING RESERVES 0, STAINES RESERVES 4

ONCE again injury prevented Manager John Martin fielding the older heads to steady his younger players in the step up to more senior football.

Staines presented one stronger sides to visit ... but in spite of the ... ade acquiring ... during the int ... the in ... Und ... hat ...

Staines' third goal came as a bad thigh injury.

Woking were unlucky when, ... dying minutes of the ... the referee penalis...

Netball
(Saturday, October 14)

BEXLEY 1, CHOBHAM 1
(Spartan League)

ALTHOUGH Chobham held the lead for most of the game, they were very lucky to get a point as Bexley posed a very real threat from start to finish. Certainly during the first half a goal to Bexley seemed inevitable as they won the majority of the high balls.

Their attacking moves called for many good saves from an improved Steve Osgood and goalmouth clearances by Mickey Elliott, Pat Folan and Phil Marlow.

Despite this good defence on Chobham's part, Bexley still had more than their share of shots just scraping the cross-bar. An early infringement by Bexley's goalkeeper saw Chobham awarded a free-kick which unfortunately did not pay off. Neither did they benefit from a chance made by Keith Lawrence when, after a fast sprint down the right, his cross was not followed up.

After 25 minutes Norman Rudd got onto his stride and ran the ball nicely past Bexley's defence to score for Chobham. Just before the interval Chobham put in a good attack but it was Bexley who at the half-time whistle had a dangerous looking move going, but this was stopped by Elliott putting the ball out of play.

PENALTY

Early in the second half came proof of the free kicks being adopted by Spartan League officials, when a impreccation on the referee by Bexley's goalkeeper, resulted in an immediate dismissal for a the game and an indirect free-kick awarded to Chobham.

Home team in vain bid

Despite appeals by Bexley for offside, Peter Hennessey later broke away but his first shot came off the goalkeeper and his second went just over the bar.

With 15 minutes left to play, a good shot by Bexley was headed clear by Elliott. Then to much amazement the referee awarded Bexley a penalty for alleged pushing by a Chobham player. From the spot Peter Raven made no mistake and Bexley were on equal terms.

The home team again came very close to scoring in the closing minutes. Chobham's last chance went to Elliott but his free-kick was superbly pushed over the bar by Bexley's substitute goalkeeper.

No surprise came after the game. The Bexley players dismantled and stored away their goal posts. It transpires they also pay for the task of training.

Chobham: Osgood, Marlow, Folan, Elliott, McGonigle, Hennessey, Rudd, Webb, Lungley, Lawrence, Finn. Subs: Riccio, Minnett.

RICHMOND VILLA 4, MONUMENT RANGERS 2

VILLA took an early lead when a ball almost on the byeline was hammered into the chamberlain.

In the second half play was confined more to midfield, but Monument got level, Villa had to fight to stay in the game. But the home side scored twice more to end up 4-2 winners.

Monument Rangers: Chamberlain, Lee, Maina, Clarke, Evans, Davies, Crooks, Mandeville. Subs: Hack, Meredith.

MERVYN W... the Woking Irish trophy... Irish Association's first golf competition at Foxhills last week. The B. & I. trophy was won by Geoff. Endicotte of West End. Above: F. O'Shea seems to have lost sight of the ball. Below: Ted Phelps drives for home.

FRIMLEY GREEN RES. 1, SHEERWATER ...
(Surrey Intermediate Cup)

SHEERWATER travelled to Spartan Leaguers Frimley Green and were unlucky to come away empty handed.

The visitors dominated the first half and as early as the first minute a Dave Steel shot was cleared off the line by a defender.

After 20 minutes Frimley took the lead against the run of play, when a ...

long throw-in was headed in by Hickman.

Sheerwater continued to attack and were unfortunate not to equalise before half-time.

After the interval Sheerwater continued to pressurise for the goal they deserved, but ...

Sheerwater Res: Annals, Ewins, Duff George, Green, ..., Steel. Subs ...

MALDEN TOWN 1, WESTFIELD 0
(Home Counties League)

FIELD must be wondering what they must do change their luck. Playing against an experience Malden side, they completely outclassed them for long periods of the match.

Town started with a strong wind in their favour, but the dash and control of Channon, Stillwell, and Jones had their defence in a shambles.

Twice in 20 minutes a Malden defender scrambled the ball off the goal line.

Field's centre half had to come off because of a twisted ankle and Dave Robson took his place, with John Rose moving to defence.

Brian Paramore and Ian Barrow were doing well in Field's defence. Good interpassing by Rose and Robson, ... space for Stillwell to get ... shot at goal, but without ... Just before half-time a ... sh to Jones was cleared. Field had ... to have sewn

... f started with ... shot at ... was there to ... save and ... missing the ... all sorts of ... defence 5.

Reserves ... out

... second ... the save ... of the match from the Frimley keeper.

Manager Tony Bristow made two substitutions which almost paid off when one of them. Dave Watts, broke through the defence and shot inches wide in the last minute.

WESTFIELD RES. 3 VIRGINIA WATER 1

THE Reserves continued their run of seven games without defeat, with a brilliant win in the Intermediate Cup.

Field quickly settled down good constructive football chances falling to Dodd and Collett.

In the 15th minute Pe Jeffries hit a long pass to An Brown who scored easily.

Virginia Water fought hard to get back into the game, but found Daly, Styles and Ni Ford in excellent form.

In the 30th minute Brown beat two defenders to score his second goal. Then a mistake by the Field left-back enabled Virginia Water to score, making it 2-1.

Just before half-time Field scored the best goal seen at Woking Park this season. He started the move deep in his half. The ball touched the players before he hit a tremendous 20yd. volley into the Virginia Water net: 3-1 to Field.

Westfield: Jeffries, Balchi Daly, Styles, Rowbotham, For Collett, Dodd P., Baldwin Brown. Sub: Dodd A

Replay will decide issue

BISLEY 3, HORSELL 3

IN extra time Bisley wen ahead. But on the turn two Peter Eyles scored to give Horsell a draw and a replay the Surrey Junior Cup.

Horsell: King, Clark, Ke burns, Povey, Eyles, Mintra att, Mercer, Harper, Inp ... Pelham, Richards.

... inside the box ... Pipe scored for the hor ... The Social keeper took ... volley up field to C ... who slotted the ball ... 1-1.

... scored again befor ... Howell four ... the home side t ...

Flying sta... for ...

WOKING... WE...

WOKING flying against ... match again ... two goals ... minutes and resulted in ...

... Grainge ... another go... midfield ... and gave them victory over a good Henley side.

Woking: Gill, Foster, Sue Bedford, Bobby Stacey, Claire Oldridge, Liz Atkinson, Liz Michael, Penny Vincy, Diane Wearing, Liz Webb, Daphne Hooper, Barbara Weston.

xt Home Match
ALDERSHOT ...TLEPOOL UNITED
turday, October 14
League Division Four

dmission to Ground
Adults £1
Senior Citizens
and Juveniles 70p

... of Geoff Parjott ... be remembered for his ... ion with North Farnboro ... tion FC. his work with the ... Woking and the District League ... and for his services to schoolboy ... football in the Farnborough ... area.

... is hoped that the game will ... supported, as it is for a ... very good cause.

... The Woking and District ... League would like to than' ... Woking FC for use of their ... facilities for a training session, ... and Barry Kimber, Woking ... FC's physiotherapist, who will ... also be present.

Woking takes command

... 5, HAMBLE OLD BOYS 2

... at a Woking ... the domination ... in this game ... against a good side ... from a higher league.

Woking started well and the goals from Preshaw and Oliver were just rewards for their efforts. The game, however, was not to be conceded lightly by ...

Continuous pressure brought about a short corner, which resulted in a penalty flick when a solid stick tackle prevented the shot being made. This was coolly converted by Browne, one of several new young players in this year's first team.

A misdirected push in from a frustrated Hants' half-back, was ...

Craig, Wren, Oliver, Preshaw, Corser, Browne.

HAMBLE OB II 5, WOKING II 2

THE teams were well matched. The score could easily have been Hamble 8, Woking 8, but it was not to be, and Hamble ended up winners on the day.

Gaps in the Woking defence allowed the second of the two Hamble forwards to score two ...

to Woking's first goal. A deceptive shot from Peirce glided past the goalkeeper when he appeared to have it covered.

Hamble failed to convert a penalty flick, the shot being saved by Wareham, but another led to the fourth goal.

A fifth soon followed with the defence very square. However, Woking were still able to reply, Burch scoring a fine goal with 10 minutes to go.

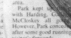

FREE ...ING for a month!
when you rent our
ECONOMY COLOUR TV

19 FERGUSON 'Colourstar' £7.80 MONTHLY

DELIVERED FOR JUST £7.80 — PAY NO MORE FOR 2 MONTHS!

A RANGE OF SIZES AND PRICES

Rent now and save — while decontrolled

'A free view is a wise view'

KETTS

drawn on the newspaper with a 3B pencil and then the background was painted. Don't try to keep to the pencil line as if it were a magnet. If you go over, it doesn't matter because the colour will cover it up. Now paint the banana using a size No. 4 nylon brush and a mix of Cadmium Yellow, Raw Sienna and White, and Burnt Umber for the spots. Use Burnt Umber and Ultramarine for the background. Keep the paint thick rather than wet, as the newspaper is porous and water will make it mushy. Once the paint is dry, it will strengthen the paper because you have put a thin layer of plastic (paint) on the surface.

The next banana (bottom left) was painted on top of primer. The paper was primed first with acrylic primer to counteract the absorbency of the newspaper. When it was dry, I drew the banana with a 3B pencil and painted it using the same colours as before.

The orange (bottom right) was painted direct on to the newspaper without priming. Mix Cadmium Red, Cadmium Yellow, Burnt Umber and White for the fruit, Bright Green and Burnt Umber for the background. This time, try using the paint very thick; use Standard Formula colours to create texture. You will also gain experience in using paint that is not quite so easy to handle as Flow Formula.

Now let's turn to brown paper; find some, and we will use that for our next exercise. I have chosen a pan for this one, for a very good reason: you will have to draw a round object instead of a square one. Here the only problem is the ellipse; that is the oval shape you see when you look at the pan. When you draw the ellipse, never give it pointed ends, the line must be continuous as if bent out of a piece of piano wire. An ellipse is a circle that gradually flattens according to your eye level. Take a two-pence coin and hold it upright in front of you: it is now a circle. Now turn it round, closing one eye; as you turn, the circle flattens and becomes an ellipse. If you look closely, you will see there are no sharp corners but just one continuous line all the way round. Instead of the clean, crisp edges of the box, you now have rounded forms which will enable you to practise moulding and graduating your colour to show a curved surface. On the pan side, you can do this by either working the paint from light to dark or by starting with the dark side and adding lighter colour as you go to the light edge of the pan. You may need to work at this pan more than once to get used to round surfaces.

And now back to cartridge paper. Find yourself a book,

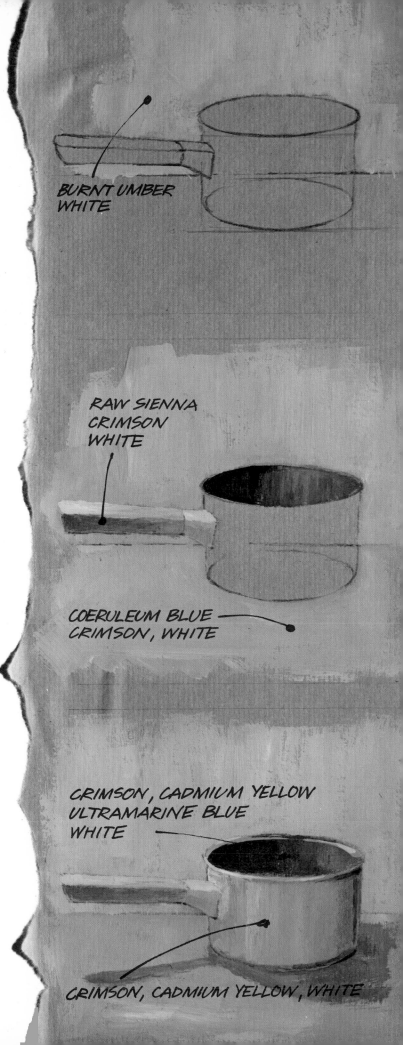

BURNT UMBER
WHITE

RAW SIENNA
CRIMSON
WHITE

COERULEUM BLUE
CRIMSON, WHITE

CRIMSON, CADMIUM YELLOW
ULTRAMARINE BLUE
WHITE

CRIMSON, CADMIUM YELLOW, WHITE

BURNT UMBER
WHITE

COERULEUM BLUE.
CRIMSON, WHITE

CADMIUM RED, BURNT UMBER
WHITE

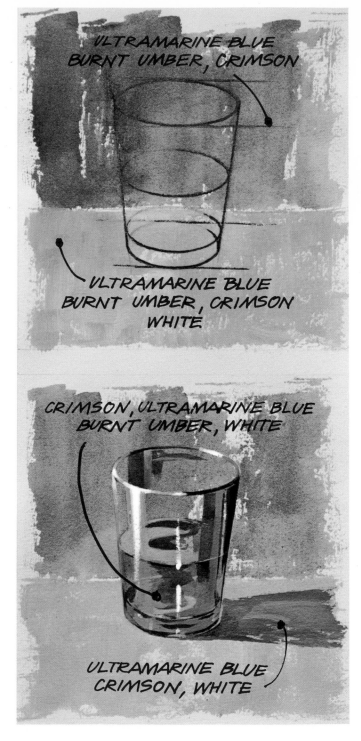

ULTRAMARINE BLUE
BURNT UMBER, CRIMSON

ULTRAMARINE BLUE
BURNT UMBER, CRIMSON
WHITE

CRIMSON, ULTRAMARINE BLUE
BURNT UMBER, WHITE

ULTRAMARINE BLUE
CRIMSON, WHITE

A book and a piece of glass – two more objects to experiment with, each presenting its own particular problems: white pages are not really white and do you honestly think that water is colourless?

preferably a plain-coloured one, and try this on white cartridge paper. We are back to the shape of our box again but this subject demands the extra skill that you should have now acquired.

Paint as usual but where you come to the pages, half close your eyes to see how dark the white pages are on the shadow side. I think you will be quite surprised to find how dark they are. Use a Series 201 brush and take it along the pages; you will find that some of the brush strokes look like the edge of the pages.

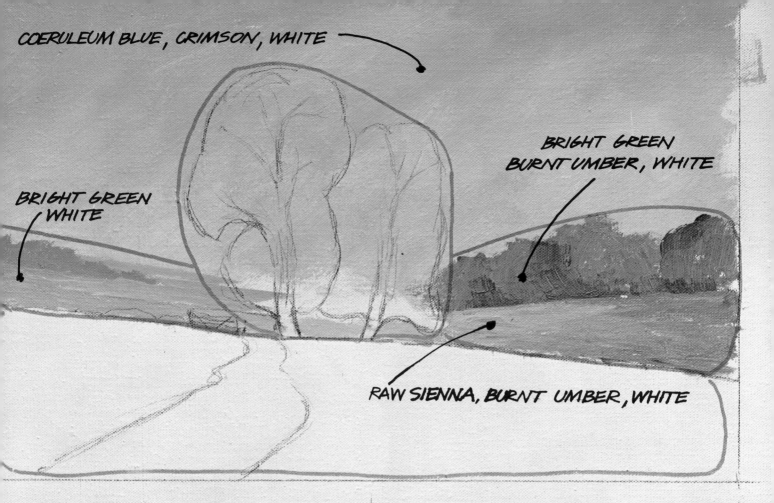

COERULEUM BLUE, CRIMSON, WHITE

BRIGHT GREEN
BURNT UMBER, WHITE

BRIGHT GREEN
WHITE

RAW SIENNA, BURNT UMBER, WHITE

Coloured Paper. Here is the trickiest so far, a glass. Use one that is plain and simple in shape; the secret lies in what you leave out, not what you put in. Paint the background thinly, to let the drawing show through. Then, working from top to bottom, put a dark tone on the shadow side of the glass. Remember the ellipse; now draw that on the top and bottom of the glass with a small sable brush. Working again from top to bottom, put in the highlight on the left.

Now try a canvas. In this exercise I have sketched on canvas a simple landscape with a tree. This is the last exercise you will do before you learn some of the different techniques of acrylic painting. It may be somewhat advanced at the moment but it will add a little spice to the exercises you have been doing. I want you to use the same methods you have been using up to now, avoiding detail and going for the shapes, colours and tones.

Draw the picture with an HB pencil and paint a clear, blue sky, using the colours shown. At a second stage, when the sky is dry, paint the middle distance. Next, using a broad treatment, paint the large tree and foreground. For the lighter greens and for the foreground try using Standard Formula; it will add texture and will help to bring the foreground near to us, pushing the background further away. Don't try to put detail in this picture, that will come at a later stage.

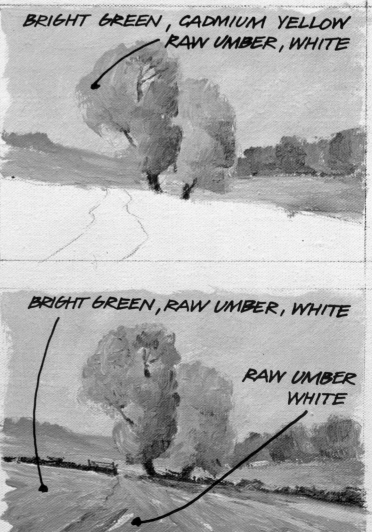

BRIGHT GREEN, CADMIUM YELLOW
RAW UMBER, WHITE

BRIGHT GREEN, RAW UMBER, WHITE

RAW UMBER
WHITE

SOME BASIC TECHNIQUES

By now you should be used to handling acrylic colour and know the feel and texture of it. While working on the previous lessions, you will have found different techniques for using the paint. This you could have done consciously or subconsciously. If you have found a way of painting a thin line with a thick brush for instance, don't think this is wrong. Generally speaking, any way you find to achieve a desired result is fine. In this section I will explain some of the techniques I use for acrylic painting.

In all the illustrations I have marked the movement of the *brush strokes* with black arrows. To indicate the movement of the brush in relation to the canvas, i.e. working from top to bottom or bottom to top, I have marked the direction with an outline arrow. For instance, if you look at the first illustration, you'll see that the brush is being moved left to right, from top to bottom.

Wet on wet

This is a name given to the method of brushing wet paint on to and into more wet paint on a canvas. This helps to mould colours into one another and graduate them evenly from, say, dark to light. On small areas, this can be done quite easily with acrylic colour, but if a larger area, say 51 × 41cm (20 × 16in), is to be painted wet on wet, use acrylic Gel Retarder, which will slow the drying process and allow wet on wet painting. Try using one brush of Gel Retarder to one of paint. You will find from experience how much you need for your own requirements. Move the brush from side to side, moulding the colours together, getting soft edges; and work from the light of the cloud, down the canvas to the darker tones.

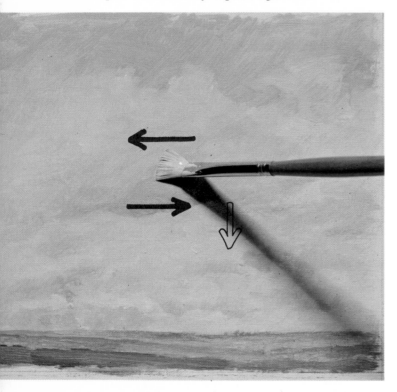

Painting thin

Painting thin is a way of painting transparently and can be done at any required time. If you paint thinly, it means that the surface will show through your paint. The surface could be the clean canvas or areas of colour. Painting thin is a way of glazing. In this example the painting thin technique is being used to paint the sky over the drawing of buildings while still retaining the drawing. To achieve this, brush the colour in more than usual and it will spread, thin out and become less opaque.

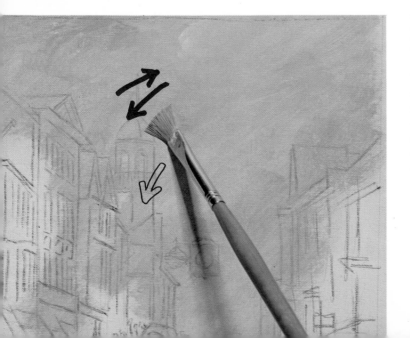

Dry brush

This is a technique applied to most forms of painting: watercolour, oil etc. It is used to achieve a hit-and-miss effect, thus giving sparkle and life to the brush stroke. Although it can be applied to many subjects in order to express certain feelings, one of its most natural areas of application is water. Dry brush can give ripples, sparkles, highlights and movement to water. The illustration shows water reflections and the dry brush is adding sparkle and movement.

Dry your brush out more than usual, load it with paint, work out the excess paint on to your palette, then drag the brush from left to right in straight *horizontal* strokes across the water. The paint will hit and miss, leaving some background showing through. For some effects you can work thick paint in a dry brush technique over the same area time and time again. This will give you depth in the area you are painting. With acrylic colour this can be done quickly as the paint is quick-drying.

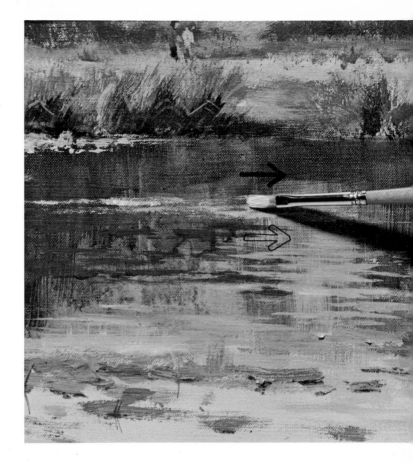

Misty effect

A misty effect in a landscape or seascape can give it a lot of atmosphere. Using acrylic colour, I have found that I can add the mist to the painting at any time, rather than having to work it in as the painting is being progressed. Since the paint dries quickly, there is usually no waiting time for this effect to take place.

Dry the brush out and add a small amount of paint, rubbing it backwards and forwards on the palette until it is very dry. It is really a very, very dry brush technique. Scrub the area to be painted with the brush and you will cover areas in mist; by continuous scrubbing you will find that, as the brush uses up most of its paint, the areas of mist now being applied will be more transparent, showing some background through. This, of course, is part of the effect. The mist on the right was painted in this way.

NB: try not to have too much thick paint left by earlier brush strokes on the surface where you intend to have your mist patches.

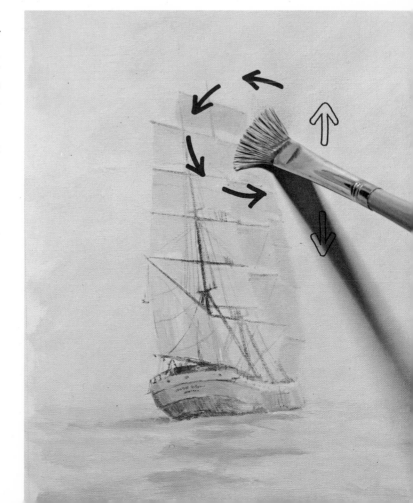

Fig. 18

Texture paste

Texture Paste is an acrylic polymer extender for building up heavy impasto textures. That is the technical phraseology! It looks and feels like a very thick, white paint. It can be put on canvas or any painting surface very thickly, two centimetres thick if required. When it sets, it is hard and can be painted over. It is extremely adhesive and an ideal medium for collage work. I use Texture Paste for foreground work where impasto effects help with moulding (see **fig. 18**).

Put some Texture Paste on your palette as you would do with paint. Lift some off with your brush and put two or three lumps on the painting. Then load your brush with paint, push the brush into the Texture Paste, press and pull away (**fig. 19**).

The ways of moulding the Texture Paste on the canvas are endless. You will find that the colour of the paint will be weaker where it was mixed with the white of the Texture Paste. If you want darker areas, paint those when the paste is dry.

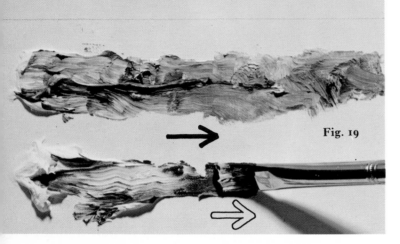

Fig. 19

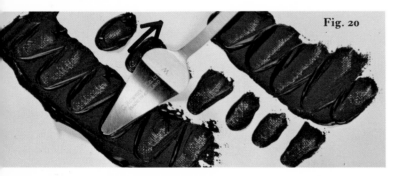

Fig. 20

Palette knife

Standard Formula colours are unsurpassed for thick impasto work. The colour can be used undiluted, with a painting knife, to create many textures and forms. The paint retains its sharp edges and will not crack, even when put on very thickly. **Figs. 20, 21** and **22** show a variety of shapes and forms that can be produced by different painting knives. In **fig. 20**, the small, pear-shaped knife is shown producing first positive and then negative shapes. The flexibility of the blade allows sensitive control. **Fig. 21** shows a medium, pear-shaped knife being used to mould forms and create surface-texture patterns. **Fig. 22** shows a narrow, trowel-shaped knife being used to cover an area with paint. Always clean painting knives after use.

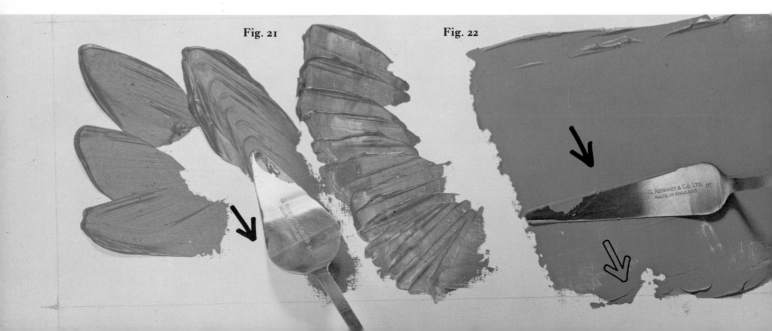

Fig. 21 Fig. 22

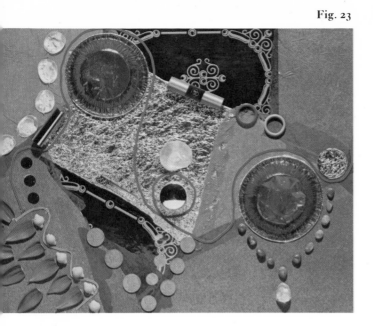

Fig. 23

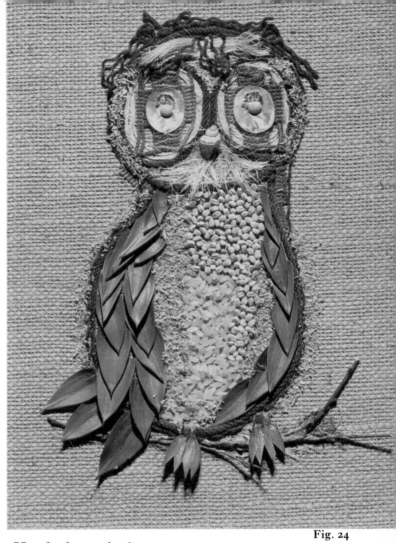

Fig. 24

Collage

The adhesive nature of acrylic colour makes it an ideal medium for collage work. The colour can be used as both a paint and an adhesive. However, there are transparent and colourless acrylic mediums on the market that can be used for gluing. One of them dries matt, the other gloss. Don't overload paint and mediums with materials such as sand or marble dust which might cause cracking in heavily loaded areas. Cracks rarely occur but if they do, they can be filled within a few hours of drying.

Texture Paste can be used to its full glory in collage work. In this context it is an ideal, thick, mouldable glue. It will hold anything in position, from a piece of paper to a lump of wood or plastic. The Texture Paste can be mixed with paint to colour it or it can be coloured when dry. In **fig. 23** (part of a finished collage work), Texture Paste has been put on the board first and heavy objects have been pressed in and left to dry. **Fig. 24** is a typical example of what can be created with acrylic colours and mediums. This delightful owl was designed and produced by my wife, using natural hessian as a support on hardboard. String, dried honesty seed pods, wool, dried parsley, barley, rice, monkey-tree leaves, lentils, shell, twigs and tin-foil were the other materials used.

Here is a more comprehensive list of materials that can be used for collage work – plastic, metal, glass, all kinds of paper, cardboard, cellophane, feathers, coloured foil and cork; all types of wood, from tree branches to sawdust; sequins, string, textiles and dried leaves. If materials used on a collage are covered with medium, they will be protected as well as sealed to the support.

Hard edge painting

Flow Formula colours have a high degree of opacity and may be easily brushed out to give flat, level areas of colour. These properties are ideal for a number of abstract techniques, hard edge painting being one of them. This is simply painting one flat colour against another with a crisp, hard edge. In **fig. 25**, masking tape was used to achieve the razor-edge sharpness between the colours. Make sure you press the edges of the tape down firmly to prevent paint seepage.

Fig. 25

Fig. 26

Glazing

Acrylic colours will produce rich, transparent glazes when mixed with a glaze medium. The more glaze medium you add to your paint, the more transparent your glaze will be. A succession of thin glazes will produce soft colour gradations and the effect of colour fusion.

In fig. 26, the three primary colours were used, starting with yellow, then overpainted with red and finally with blue. This gives secondary colour effects where the primary ones have crossed each other. In this illustration, a mixture of one part colour to ten parts of glaze medium was used.

In fig. 27, a glaze was applied to a conventional painting to achieve the smoke effect. Use the brush as in the misty effect but this time, add glaze medium. This allows the paint to move better on the canvas because it is wet with the medium. It also makes sure that the paint is truly transparent. That part of the painting that has been glazed will look glossy and the rest will be matt. When you varnish your painting, this difference will disappear as the whole picture will be glossy or matt, depending on which varnish you use – a matt finish or gloss finish.

Fig. 27

Staining

Flow Formula colours can be diluted with water and painted into unprimed canvas to get an even, matt surface of colour. An acrylic, water tension breaker can be added (this is a medium for helping the flow of paint on to the canvas when very large areas are to be painted or the surface of the support is very, very porous and must stay that way, as in the unprimed canvas in this exercise). Water tension breaker, when added to the water, will give minimum dilution of the colour, at the same time retaining maximum colour intensity. This technique gives the appearance of a stained canvas, rather than a painted one (see fig. 28).

Fig. 28

Fig. 29

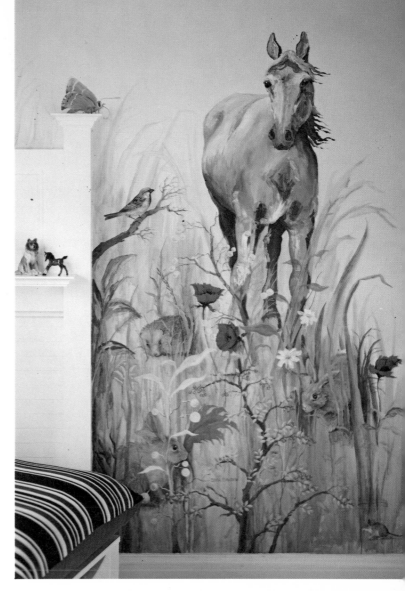

Murals

Acrylic colours are particularly suitable for mural painting and can be applied directly to plaster or masonry as well as to canvas without prior preparation of the surfaces. Depending upon the quality of plaster or cement, it is preferable to prime it with an acrylic primer, although this is not absolutely necessary. **Fig. 29** is a mural that my eighteen-year-old daughter painted on her bedroom wall; Flow Formula was used entirely for this painting.

Priming

Priming is a method of sealing absorbent surfaces before applying paint. Acrylic primer should always be used. Use a small, household brush to paint on the primer (**fig. 30**) or, for larger areas, a household squeezy painting pad. Try to avoid leaving brush strokes on the surface, brush them well out. Wash your brush out after use. I am often asked if paper should be primed: the answer is no.

Techniques - to sum up

In the foregoing pages I have tried to show you some of the basic methods of getting different results on canvas. If you can imagine all the brush strokes or painting knife strokes that occur during one painting – it must be tens of thousands – and all the variations that may occur, it must be obvious that I have only picked out the *basic* techniques. You will discover many of your own and you will add these to your reservoir of knowledge. Whatever you learn, either by accident or design, don't be afraid of using it if it helps your painting. If you stood on your head to paint and the result was disastrous, people would laugh at you but if the result was good, then people would marvel at you. Never worry *how* you paint it – *if* the result is good.

Fig. 30

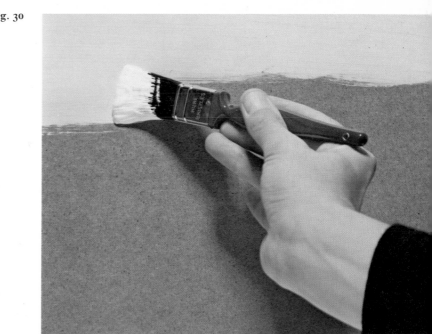

MORE ADVANCED WORK

Well, we have come a long way so far and by now you will either want to rush on to the next stage or want to keep trying some of the earlier exercises. Remember, I do not want you to run if you can't walk! So if you feel like concentrating on more exercises, carry on, then come back to this page when you are more confident.

I have taken seven subjects in the following pages and worked them through various stages for you to follow and copy, if you wish. I have explained how the work was done and, most important, I have kept to the same painting from the first stage to the finished stage. This is important because it allows you to see the *same* painting through its four stages of development, so that you can compare any stage with what was done earlier. Also, it is important to know the size of the finished painting (not of the reproduction) as this will give you a relative scale to adjust to. I painted all the pictures on a 51 × 41cm (20 × 16in) canvas primed with an acrylic primer. The close-up illustrations for each exercise are reproduced the same size as I painted them. This gives you the chance to see the actual brush strokes and the detail that was put in. Finally, I have illustrated the method used for a particular part of the painting that I think you need to see more closely.

Now, before you dash off to start an exercise, I will answer two or three of the most important questions I am constantly asked with reference to acrylic painting. One of the most common questions is: What do you think of painting from a photograph? or, Is it correct to paint from a photograph? It is such an obvious question in this modern age. I always answer like this: I am sure that had the old masters had the use of a camera, a great percentage of them would have used it. They would have used it in two different ways; firstly, for instance, to 'freeze' a waterfall to see what it looks like when still. The same would apply to a wave, a sunset and so on. *We* take these things for granted because we have always been able to look at still pictures of moving objects. But before the camera was invented, artists couldn't do this. It wasn't until the advent of the camera that horses' legs could be seen 'frozen' at a gallop. Now we can also see them in slow motion or even in backward motion.

Secondly, I believe the camera would have been used by the detail artists. If you were out painting a very complicated boat scene and some were likely to move off before you had the picture finished, then no matter how brilliant an artist you were, if your subject had gone you couldn't paint it, let alone put in detail. But if you had taken a photograph of the scene as you sat down to paint, you would always have the detail you needed. The painting could be started outside without the worry of getting all the detail in; you could concentrate on the picture as a whole, getting the feel of the atmosphere, and could put in the detail later at home, with the aid of the photograph if necessary. These are the reasons why I believe that the camera would have been used and by now, in 1979, it would all be accepted. In certain respects it is still frowned upon, but as an *aide-mémoire*, I think a photograph (if you *take it yourself* while *you* are sketching or painting the subject) is a great piece of additional, modern equipment. Do not let it become the master, however – *nature is the master*.

Another question very commonly asked is: Can acrylic colour be used over oil colour? The answer is no, but you can paint oil over acrylic once the acrylic is dry. Another one: Can you mix different brands of acrylic colours? It is not advisable to do this as different brands contain different qualities and types of resin and some are incompatible with one another. Your picture may stay tacky.

Finally, back to the exercises: I have, quite naturally, painted these subjects in my own style which has evolved over the years. The way I paint in this book is the way I work; I haven't made the paintings work for the book. But remember, we all have a creative style of our own and this will come out naturally. Once you have mastered the medium, in this case acrylic colour, then let your own style come to the fore.

The set of colours shown on the first page of each exercise comprises the main, basic primary colours or mixed colours used in that particular exercise.

Now on with the exercises and good luck.

DO'S AND DON'TS

ALWAYS PUT THE CAP BACK ON THE TUBE AFTER USE

KEEP YOUR NYLON BRUSHES IN WATER ALL THE TIME

ALWAYS PLACE YOUR COLOURS IN THE SAME POSITION ON YOUR PALETTE

REMEMBER THE 'LIGHT AGAINST DARK' PRINCIPLE

REMEMBER 'WET ON WET' FOR TONE GRADATION —
USE GEL RETARDER IF NECESSARY

USE THE 'DRY BRUSH' TECHNIQUE FOR RIPPLES, SPARKLES,
HIGHLIGHTS, ESPECIALLY ON WATER

ALWAYS RETURN YOUR BRUSH TO THE WATER IN THE BRUSH TRAY
AND DRY IT WELL WHEN YOU TAKE IT OUT

SPREAD THE PAINT THIN FOR TRANSPARENT EFFECTS

REMEMBER TEXTURE PASTE FOR MOULDINGS, FOREGROUNDS,
RELIEF WORK, COLLAGE

ALWAYS BUY THE BEST QUALITY BRUSHES YOU CAN AFFORD

MIX GLAZE MEDIUM WITH YOUR PAINT FOR TRANSPARENT COLOUR —
TRY THIS TECHNIQUE FOR SMOKE EFFECTS

DO NOT USE ACRYLIC COLOURS OVER OILS

DO NOT ATTEMPT TO MIX DIFFERENT BRANDS OF ACRYLIC COLOUR

REMEMBER OBSERVATION IS THE KEY TO GOOD PAINTING

AND, TAKE IT EASY — PRACTISE, PRACTISE, PRACTISE AND
DON'T RUN BEFORE YOU CAN WALK !!

EXERCISE ONE
STILL LIFE

For your first exercise I have purposely chosen a still life subject. During your first lesson on painting simple objects, you started with a brick; this was comparatively easy to find but above all, it could be painted under your own conditions. This is the beauty of still life, you can control the lighting, size, shape and colour of your subject. If you use inanimate objects, you can keep painting the same ones for years without their changing in any way. To avoid your spending that long on your still life, I have added some fruit and vegetables. Before we begin, here are one or two important notes on still life painting. Don't be too ambitious to start with. Set up just a few simple objects and put them on a contrasting background. The best light source is an adjustable lamp, which can be directed on to your subject to give maximum light and shade (light against dark). Half close your eyes and you will see the darks and lights in strong contrast. When you set up a still life subject,

make sure that any of the objects you use will not be needed by you or your family in the near future. If you have your subject on a board and it has to be moved, fix the objects with plasticine, drawing pins, Blu-Tack or staples.

First stage The light source is coming from the left and above. This can't be seen in the illustration as I have not drawn in any shadows. To start, draw the line that divides the background from the flat surface, put the vase in, the line of the cloth, the marrow and then the onion, lemon and orange. Now, using a mixture of Raw Sienna, Crimson, Ultramarine and plenty of White, paint the background using your size No. 12 nylon brush. For the table surface use the same colours but add much more White as this area is getting direct light from the light source. Paint thinly over the drawing so as not to lose it. *In this exercise and all the others to follow, it is important to know that when mixing colours, the first colour to mix into is the one I write first:* add the other colours (smaller amounts) to this one. The first colour is usually the one representing the main colour. White is last unless, of course, White is the main colour.

Second stage The colours to use for the vase are Raw Sienna, Burnt Umber, Crimson and White. Study carefully the delicate tones, highlights and shadows; use your size No. 4 nylon brush for the rim and inside. Paint from the light side of the inside of the neck to the dark side, adding the shadow while the paint is still wet (use a little Ultramarine to darken the shadow). Now, with a size No. 8 nylon brush paint down the vase, letting the brush follow the ellipses. This will give the vase that hand-made feeling as the brush strokes follow the natural way the vase was turned. Paint the vase as though the dark brown pattern didn't exist. Now paint the dark pattern over the vase, using Burnt Umber mixed with a little White and your size No. 4 nylon brush. Mix Bright Green, Cadmium Yellow, Burnt Umber, Ultramarine, Crimson and White for the cloth. Five colours and White seem quite a lot for painting one colour but remember, the basic colour is green made from Bright Green, Cadmium Yellow and Burnt Umber. The other colours are there to help to give it light and shade, to stop it looking flat and help it to look real and alive. *This, of course, applies to all the exercises.* Start painting from the left of the vase and work down, adding dark and light and painting the folds and shadows. Use a dry brush technique to recreate the texture of the material. Next, add the shadows of the vase and marrow: use a size No. 4 nylon

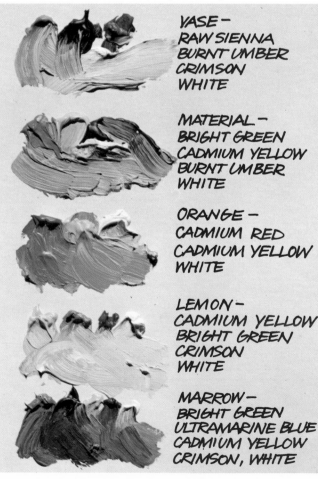

VASE —
RAW SIENNA
BURNT UMBER
CRIMSON
WHITE

MATERIAL —
BRIGHT GREEN
CADMIUM YELLOW
BURNT UMBER
WHITE

ORANGE —
CADMIUM RED
CADMIUM YELLOW
WHITE

LEMON —
CADMIUM YELLOW
BRIGHT GREEN
CRIMSON
WHITE

MARROW —
BRIGHT GREEN
ULTRAMARINE BLUE
CADMIUM YELLOW
CRIMSON, WHITE

First stage

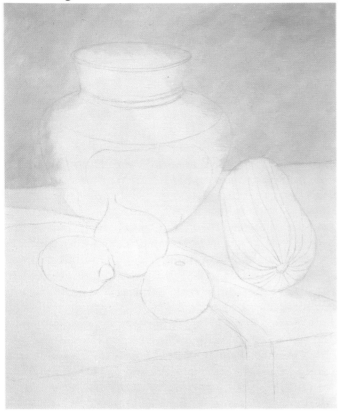

Second stage

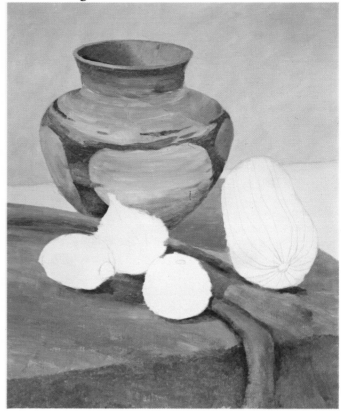

brush with Ultramarine, Crimson, Cadmium Yellow and White. Note how the shadow is lighter towards the back.

Third stage Using your size No. 8 nylon brush, mix Bright Green, Cadmium Yellow, Crimson and White, and paint the light green of the marrow, letting your pencil lines show through. Now the onion: mix Cadmium Yellow, Crimson and White and use your size No. 4 nylon brush. Start at the top of the onion and let your brush strokes form the veins of its skin. The darker area is a piece of skin coming off: add a little Ultramarine to paint this. Now the lemon: use the same brush and mix Cadmium Yellow, Bright Green, Crimson and White. Start with the highlight near the top left and work down into the shadow areas. Work the ends of the lemon very carefully and add the dark accents to show their shape. Note the reflected light on the bottom where it meets the shadow; add this highlight. Paint the orange in the same way, using the same brush (after washing it out) but mixing Cadmium Red, Cadmium Yellow, a little Crimson and White. Remember the reflected light at the bottom as on the lemon.

Finished stage Start with the marrow, using your size No. 4 nylon brush and mixing Bright Green, Ultramarine, Cadmium Yellow, Crimson and a little White. Paint the dark stripes, letting the brush miss the light areas, thus creating the speckled, light shapes. Look carefully and add

Third stage

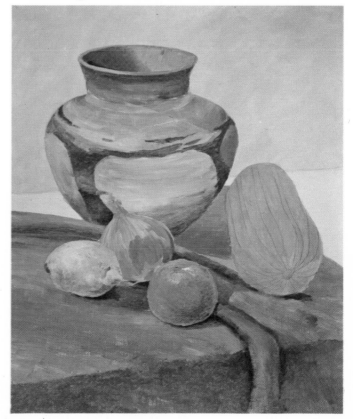

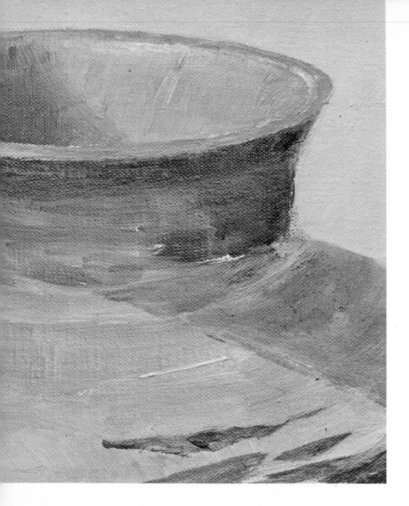

the shadow cast by the vase. Use Ultramarine, Crimson and Bright Green and paint over the marrow transparently. Using the same colour, paint the right-hand, shadow side of the marrow and the front. It will acquire form and recede into the picture. Paint transparent washes on the onion with your size No. 5 sable brush to give the skin a transparent look. With a small sable brush mark in some veins. Now darken the shadows on the cloth with your size No. 4 nylon brush, using Ultramarine, Crimson and Bright Green. Then, with Standard Formula colours Bright Green, Cadmium Yellow and White, and a size No. 8 nylon brush, work in the light areas quite freely. With your size No. 2 Series 220 nylon brush and the colours originally used for the lemon, stipple the highlights and shadows on the lemon; then finish off with a small sable brush. Use the same treatment for the orange. Darken the shadows that you have already put on the vase; use the paint thinly. Also, darken the shadow cast by the vase and marrow. Draw the bull in pencil and then paint it with your size No. 1 sable brush: first a dark line, then on the highlight edge paint a yellowish white, broken line and on the opposite edge a middle-tone line, transparently. This will give the illusion of an engraved contour. Finally, look at your work and add some more dark or light accents where you feel it helps to make it read. When you paint your own still life, remember to half close your eyes to see light against dark.

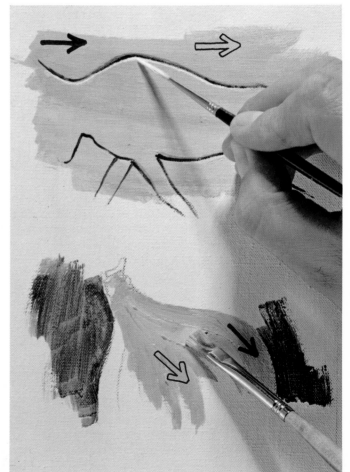

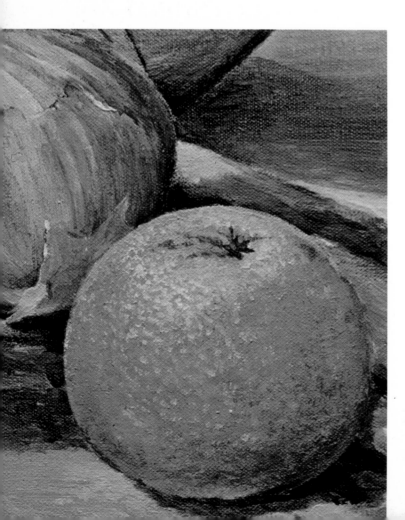

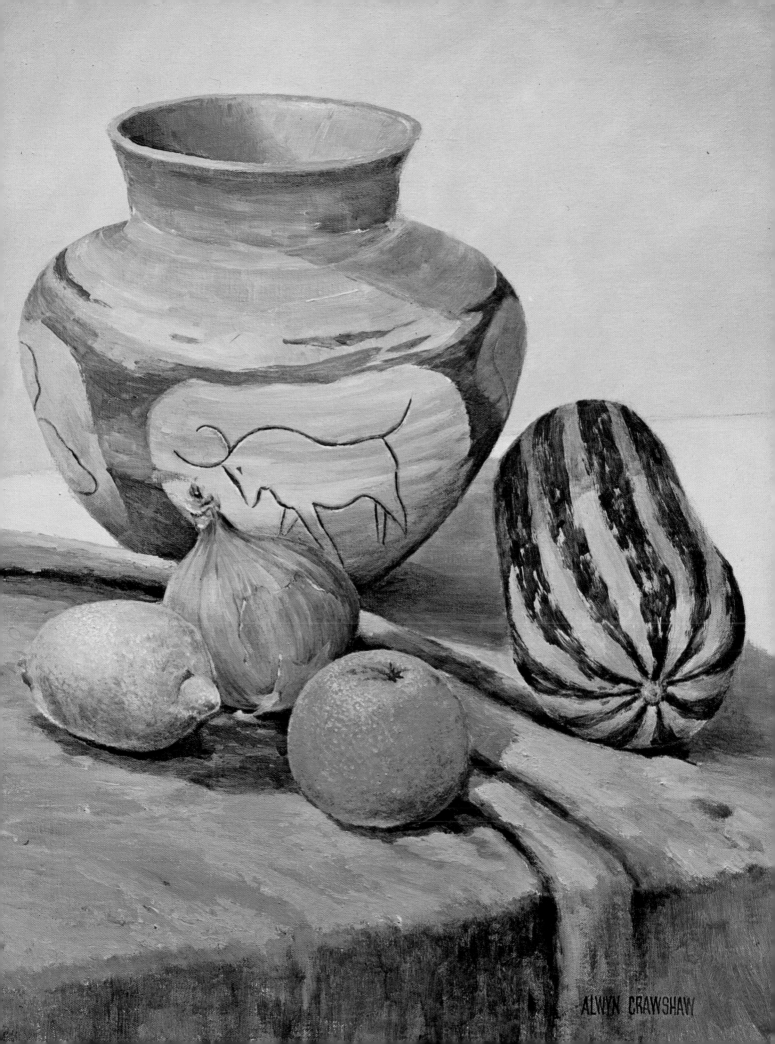

ALWYN CRAWSHAW

This exercise is also one that can be controlled to a large degree by the artist. The one main point to remember is that flowers change and eventually die. Therefore, any arrangement you prepare must be capable of outstaying your painting time. If you do not manage to finish in time, change the flowers for fresh ones: your painting should have progressed enough for you to improvise. Remember, it is an *impression* of a flower you are painting, not a *specific* one. A vase of different blooms, with exciting shapes and colours, can give tremendous inspiration and make a fine painting. It can also be very overpowering for the beginner, leading to disaster and disappointment. Study one flower at a time. Observe its characteristics, see how its petals are formed, their shape, how it grows from the stem and, just as important, study the leaves. Put this one flower against a plain and contrasting background, which will give it a clear, undisturbed shape. When you have mastered a certain flower put some in a vase and paint away. You will find it helpful, at times, to use other colours in addition to the ones on your palette, as the pigmentation of flowers is unlimited. For this exercise I have chosen flowers that can be painted with your normal palette (see the basic colours below).

First stage The source and angle of the light are the same as in the still life. Draw the line between background and table top first, then the teapot and finally, the flowers and leaves. The large leaves, incidentally, are rhododendron and will last a long time. Using Raw Sienna, Cadmium Yellow, Crimson and White, paint the background; remember to paint thin where you want your drawing to show through.

Second stage For the leaves, mix three tones of dark, medium and light green on the palette, using Bright Green, Ultramarine, Cadmium Yellow and a little White (medium); add more White (light); add Crimson and more Ultramarine (dark). Paint the leaves with a size No. 4 nylon brush, wet on wet, working the brush into the centre, then down each side in turn, following the direction of the veins. With a mix of Cadmium Yellow, Crimson and a little White, paint the orange flowers with a size No. 4 nylon brush. Start at the centre and work the brush up and down to form petals, going round the centre and spreading out to the extreme edge of the flower. Remember: the centre of the flower is not necessarily the centre of the drawn flower shape. Continue in the same way with the yellow flowers, using Cadmium Yellow, Raw Umber, a little Crimson and White.

Third stage Now the table top: I have purposely used a non-shining surface, so you only have to contend with shadows and not reflections as well. Mix Raw Umber, Crimson, Raw Sienna and White; using a size No. 12 nylon brush, paint from the background down to the bottom of the canvas. Don't try to paint *up to* the teapot with your size No. 12 brush; let the brush go *over* the pencil lines; the excess will be covered when you paint the pot. Using a size No. 8 nylon brush, mix Burnt Umber, Crimson, Ultramarine and a little White, and start on the teapot. Keep your brush flat and move it down the pot. Bow the shape of the stroke as the pot is curved. Work in the lighter areas as you paint and add some orange and yellow for the flower reflections. The shadows on the background are the next stage. Use your size No. 4 nylon brush; mix Raw Umber, Crimson, Cadmium Yellow and White. The brush strokes should follow the direction of the cast shadow. Now the table top shadows: change to a size No. 8 nylon brush, mix

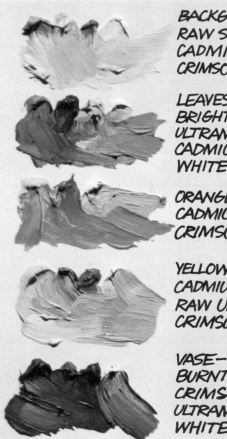

BACKGROUND—
RAW SIENNA
CADMIUM YELLOW
CRIMSON, WHITE

LEAVES—
BRIGHT GREEN
ULTRAMARINE BLUE
CADMIUM YELLOW
WHITE

ORANGE FLOWERS—
CADMIUM YELLOW
CRIMSON, WHITE

YELLOW FLOWERS—
CADMIUM YELLOW
RAW UMBER
CRIMSON, WHITE

VASE—
BURNT UMBER
CRIMSON
ULTRAMARINE BLUE
WHITE

First stage

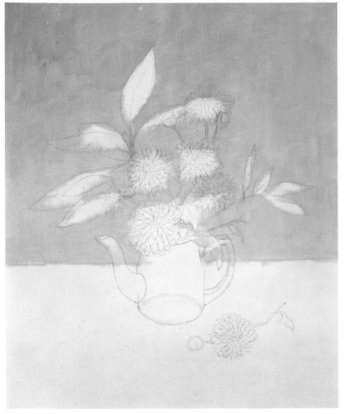

Second stage

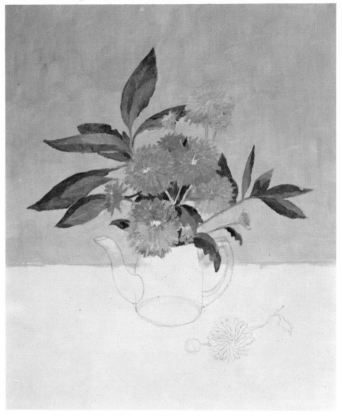

Raw Umber, Ultramarine, Crimson and White. Keep your brush strokes horizontal to make the shadows look flat. Be *very* careful to meet the background shadows spot on. This helps to give the picture two definite planes, i.e. the perpendicular background and the horizontal plane of the table. Where the shadows have gone over the teapot, use your size No. 5 sable brush and paint the edge back on to the teapot. You can see where I did this on the bottom left edge of the spout.

Finished stage Start by working on the flowers. To achieve the appearance of hundreds of petals while showing only some, you should realize the importance of light against dark. Look at the top, right-hand flower. The dark shadow on the leaf underlines the shape of the light flower and the two bright petals against the dark petals beneath stress the bottom edge formation. However, the same flower has lost some of its contour into the background at the top and right-hand sides. This has been done to give depth to the flower: if sharp accents were everywhere they would cancel each other out and no accents at all would give a very flat picture. This secret of knowing what to put in or leave out, especially in painting flowers, will come from *observation* and practice. In the meantime, as you copy these flowers it will help you understand your first painting from life. You have already painted the light and dark areas; now, using a size No. 5 sable brush, mix Cadmium Yellow, Crimson and White, and add the light areas

Third stage

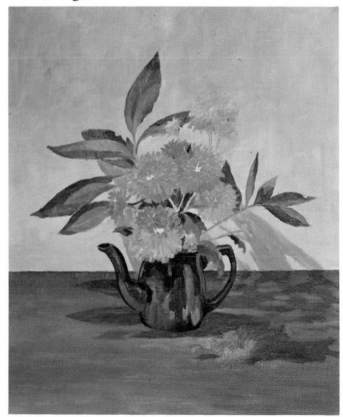

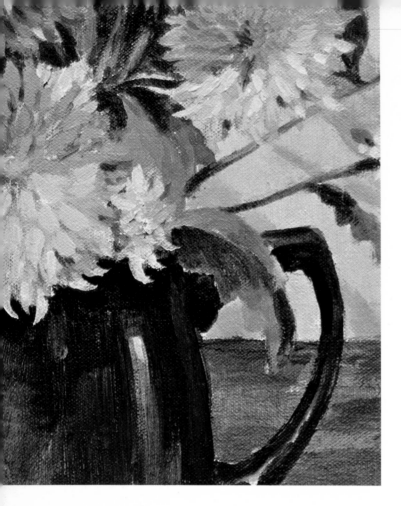

Finished stage

of the yellow blooms. Follow the shapes you have already painted in the second stage but this time, be more careful and precise with the petals. Work from the centre outwards: press the brush down, pull it towards you and slowly lift off; practise on some scrap paper, it's well worth it. Make sure you make some nice petal shapes against the teapot – light against dark! Do the same exercise with the orange flowers. Finish all flowers by adding some dark accents to help form the petal shapes (sable brush) and add some extra highlights by using Standard Formula. This will then stand in relief off the canvas and catch the light, providing those very important light accents. Now darken some of the leaves to give them form. Paint over the stems in the middle: this will give them tone, enabling them to recede. Paint in the fallen flower on the table now – watch for the light petals against dark. Glaze the teapot with a blend of Burnt Umber and Crimson, using your size No. 5 sable brush. When the glaze is dry, paint back the yellow reflection and the highlights and add some dark accents. When you have finished, it is advisable to leave the picture for twenty-four hours or so and come to it again with a fresh eye. You will then see things that you had not noticed before. You have only to correct these and then your painting is finished.

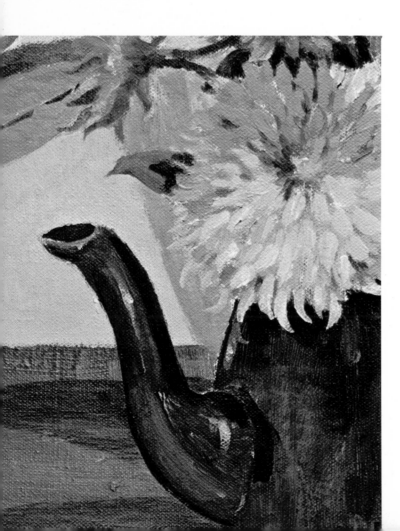

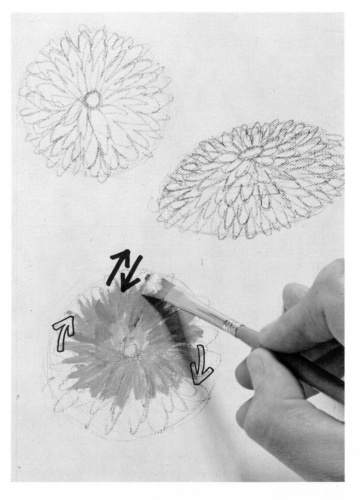

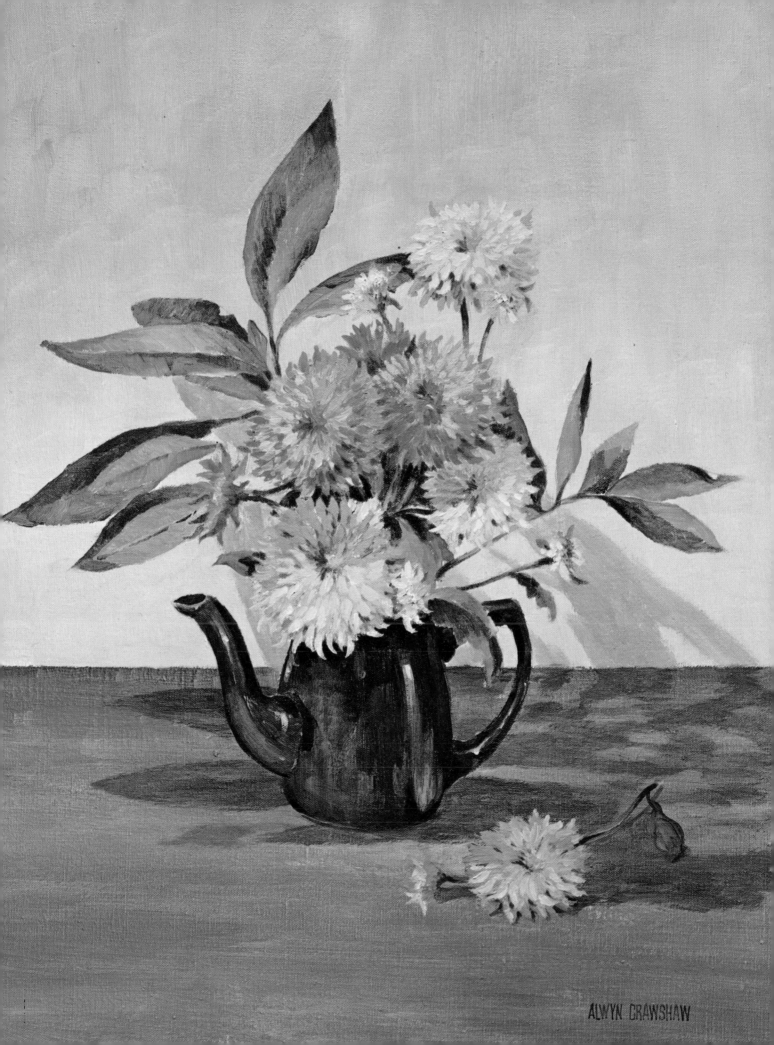

ALWYN CRAWSHAW

Fig. 31

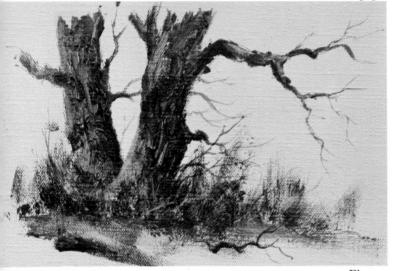

Fig. 32

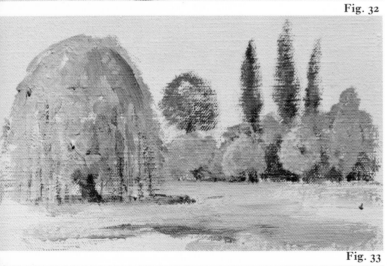

Fig. 33

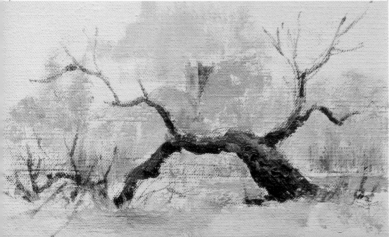

NOTES ON TREES

For the landscape artist, the tree is nature's most valuable gift to assist with the composition of a picture. For instance, one lone tree can make a picture. Trees can be used to break the horizon line; they can be positioned to stop the eye going forward or to lead the eye into the picture. When you next go out to sketch, instead of drawing a scene, pick out a good tree – one that shows the characteristics of its species – and draw it. Don't sketch it, make a very careful study, trying to draw all the branches you can see. By the way, the best time to do this is when the trees have lost their leaves and you can see their shape. By drawing carefully and *observing* the tree, you will get used to the growth pattern. This will help you when you draw trees with leaves on. In the summer, look carefully at a tree in full leaf and see how many large and small branches are showing – if you haven't bothered to take note before, you will be surprised how many can be seen against the foliage. This is important because, in a painting, these branches against leaves help to give the tree depth and interest. Start by drawing one type of tree and really making a study of it. If you then paint from memory or imagination indoors, you will always have a tree that you can paint. It is far better to perfect one species than to attempt three or four different types and find they all look like nothing on earth! You can get a real feel of the bark on the tree trunk by using Standard Formula colours – only use these on foreground trees as the texture you create brings the trees closer; you can't have your distant trees coming to the front of your painting! In **fig. 31** you can see how this texture is achieved. Use Standard Formula colour and plenty of paint, work the brush up and down the tree (mostly up) and the texture will be formed. There is a problem with trees – how to make them appear to grow out of the ground. Unless the tree is on a lawn in a park, it will usually have growth of one kind or another at its base (**fig. 32**). This natural cover enables your tree trunk to *grow* out of the ground without showing the actual base. When you are painting trees in the middle distance, you can't neglect them just because they are a long way off. Carefully observe them, pick out the different shapes and think about them (see **fig. 33**). A tree can form the basis of a composition for a painting, as in **fig. 34**. I saw this fallen willow with Dedham Church in the background: a different view of the church tower created overnight by nature. Always remember when painting trees: paint them with feeling – they are alive, not just planks of wood.

Fig. 34

NOTES ON WATER

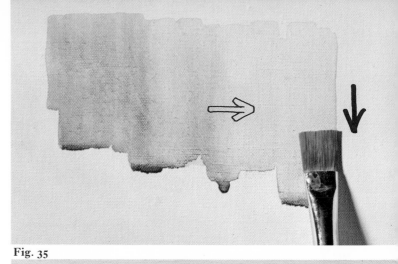

Fig. 35

The colour of water is normally a reflection of the sky and the immediate surroundings. In very clear and still water the reflection of a building can be mirror-like, therefore the water is painted as a building upside-down. This is important: the reflection goes *down* vertically into the water not across the surface. It is only movement of the water that shows as horizontal lines. Any movement breaks up the reflected images. Light on moving water is also seen horizontally. The first golden rule for painting water is to make sure that all movement lines or shapes are *perfectly horizontal* on the canvas, otherwise you will have created a sloping river or lake. When starting to paint water with acrylics, use the paint like watercolour – very, very watery – and move your flat nylon brush from top to bottom, left to right, as in **fig. 35**. The colour of this first wash is dependent upon the reflections in the water. It might be necessary to paint more than one wash to get the depth of tone required; this is fine, in fact it can give more feeling to the water, but let each wash dry before applying the next. Using the paint in this way, i.e. very thinly, it can be quite simple to create the illusion of water. In **fig. 36**, the water of this puddle was painted as in **fig. 35**, except that the tone was much lighter. Then dark colour was painted around to represent earth or muddy path, as you will do in the landscape painting. On the left-hand edge some very dark areas were painted with a small sable brush, to express shadows. The third sketch, **fig. 37**, was done in exactly the same way, except that the water was painted dark and the path light. Find some paper and practise this technique, you will find it very valuable and very rewarding. In the exercise on boats, the water of the harbour will be painted in this way. When you have movement on the water, i.e. ripples or small waves, paint the water first as in **fig. 35**. This applies to large lakes or small puddles. Then, with a small brush, paint the different tones over the water. Let the brush strokes create the effect of movement – the more broken the water the more brush strokes you will need. In this case, you may find that seventy-five per cent of your original wash is covered up. But it is this wash that holds it all together and helps to create the illusion of water (see **fig. 38**). If you are painting water with no distinct reflections and the water needs one to make it read, then put one in: a post, a fence, a fallen branch. A reflection gives the illusion of water immediately. *Observe* the moods of water at different times. Sit in the bath and wiggle your toes, let the tap drip – a lot can be learned in comfort!

Fig. 36

Fig. 37

Fig. 38

Landscape painting holds the romantic promise of a day spent in the countryside, painting away, enjoying ourselves to the full. This applies to many artists, but not to all. If you lack confidence, start with a small sketch book, tuck yourself away behind a tree, make a quick drawing of a scene you would like to paint and mark the main colours in pencil. Then paint it at home. You will thus get used to working outside, without looking like a portable studio. As your confidence grows, take your paints outside with you. Remember that nine out of ten people who take the trouble to come to see you will be full of admiration for you and your work. Sketching in pencil also applies to the person who can't often get outside. Rather than always *painting* when you do go out, make some pencil sketches; six of them could be completed in a day. Then, when it's stay-at-home day, you will draw information and knowledge from your six landscape sketches. To progress with landscape painting you must not neglect nature. Even in a

town, fortunately, the sky can always be seen and painted from a window; but you must sketch and paint the countryside as much as possible from life. Always have a sketch book with you: even if you only have ten minutes to sketch a scene and only draw ten lines, you will have had to observe it. The important factor is observation: the knowledge it provides will be committed to memory and you will find, in time, that you are capable of painting from memory indoors. The landscape I have chosen for this exercise covers the two most important aspects of nature: the sky and the ground.

First stage After drawing the horizon line, draw the two sloping fields left and right of the path, then the path, the two main trees and finally, the trees in the left, middle distance. For the sky, mix Ultramarine with Crimson, Raw Umber and White. Start at the top and work down the canvas, using a size No. 12 nylon brush. Then, with the same brush not washed out, darken the colour by adding a little Raw Sienna to give it a bit more body and paint the darker clouds. Wash the brush and mix Cadmium Yellow, Crimson and White and paint the lighter cloud area down to the horizon. As you get nearer the horizon, add more Crimson and, to the right of the trees, a little more Ultramarine. For this sky use Gel Retarder to help you with the wet on wet technique you will have applied.

Second stage Paint the light coloured field in the middle distance, using a size No. 2 Series 220 nylon brush and Raw Sienna mixed with White. Next, add to it a little Ultramarine. Using the same brush in a dry brush technique, drag it along the top edge of the field to form the distant hedge. Now, using a size No. 4 nylon brush, mix Ultramarine, Crimson, Cadmium Yellow and a little White: apply the dry brush technique and paint the trees on the left and right of the path. Don't put any detail in yet and don't worry about the funny shapes the brush makes at the bottom: they will disappear when you paint the field. Do this with your size No. 4 nylon brush, using Bright Green, Burnt Umber, Crimson and White. Paint a darker area underneath the trees. Now use Standard Formula colours Raw Umber, Cadmium Yellow, Bright Green and a little White for the left-hand tree (it has caught the sun half-way up the trunk). Start with *plenty* of paint and a size No. 4 nylon brush, working up the trunk and painting branches until the brush is too big. Change now to a size No. 5 sable brush Series 43 and continue painting the branches. Always work up and out when painting branches, in the direction in

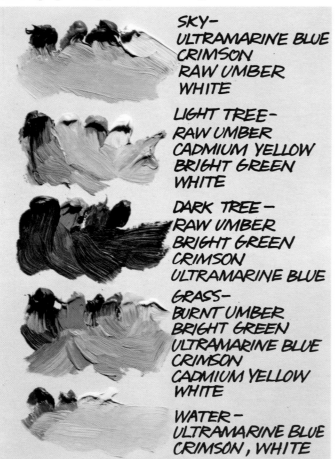

SKY—
ULTRAMARINE BLUE
CRIMSON
RAW UMBER
WHITE

LIGHT TREE—
RAW UMBER
CADMIUM YELLOW
BRIGHT GREEN
WHITE

DARK TREE—
RAW UMBER
BRIGHT GREEN
CRIMSON
ULTRAMARINE BLUE

GRASS—
BURNT UMBER
BRIGHT GREEN
ULTRAMARINE BLUE
CRIMSON
CADMIUM YELLOW
WHITE

WATER—
ULTRAMARINE BLUE
CRIMSON, WHITE

First stage

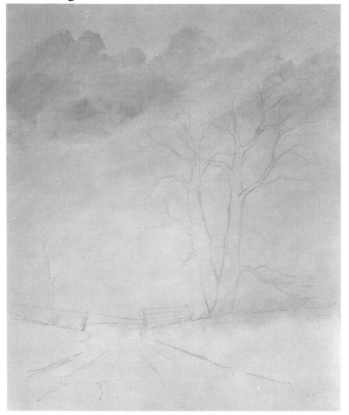

Second stage

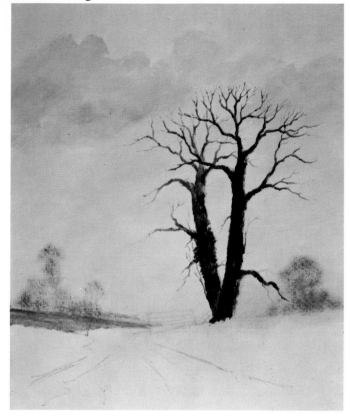

which they grow. Now paint the right-hand tree, using Raw Umber, Bright Green, Crimson and Ultramarine. When painting the trees, you will have noticed that you had the background coming through in places. This is correct and if your brush is worked up and down the trunk, it gives the impression of bark. Don't worry about light and shade, this will be added later, but remember: the light is coming from the left. The more Standard Formula paint you use on the trunk the more relief you will get: bark, gnarls, lumps and bumps. Only use thick paint on close-up trees, not ones in the distance as these will otherwise jump out of the picture instead of staying quietly where they belong.

Third stage Begin with a *very* dry size No. 8 nylon brush and paint the feathery branches on the left-hand tree. Move the brush down to form the top shape and as you get into the tree, let the dry brush strokes follow the growth of the branches. Use Cadmium Yellow, Crimson and Raw Umber. For the right-hand tree, which is darker, use Ultramarine, Crimson and Burnt Umber. Using the same dry brush technique, add the hedge. Push the brush up the canvas in the direction of growth. Add Cadmium Yellow to the colours used for the right-hand tree. Now, using Ultramarine, Crimson with a little Raw Umber and White, very watery, and a size No. 8 nylon brush, paint the water area in downward strokes. Finish this stage by using your size No. 4 nylon brush and adding some brush strokes on the foreground field to show its contours; use Raw Umber and Bright Green.

Third stage

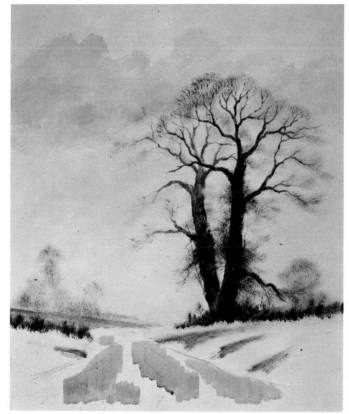

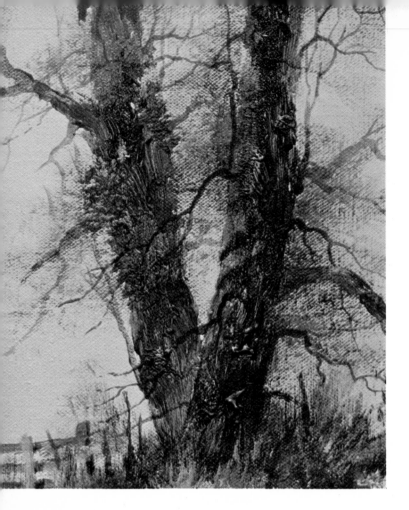

Finished stage

Finished stage Start underneath the hedge on the right and paint the field. Use Texture Paste technique with Bright Green, Burnt Umber, Crimson, Cadmium Yellow and Ultramarine. Work your size No. 4 nylon brush in the direction of the contours of the field. Flick the brush up into the hedge occasionally to break straight lines. Paint the path next, using the same size brush and blending together Raw Sienna, Raw Umber, Burnt Umber, Crimson, Ultramarine and White. Drag the brush loaded with paint into some Texture Paste and then down the edge of the puddle. The Texture Paste and paint will form a very natural edge for the water. While this area is drying, with your size No. 2 sable brush paint the small branches of the large trees, starting with the left-hand one. With a dry brush technique work in the highlights on the trunk and branches, then with your size No. 5 sable brush, using watery paint, apply the shadows. With the same sable brush, and a dry brush technique, mix Ultramarine, Crimson and White, and paint the main trunk and branches of the left-hand, middle-distance tree. Paint the gate and fence using a sable brush with Raw Umber, Bright Green and White. Add the shadows at the bottom of the path with a size No. 5 sable brush, using watery Ultramarine and Crimson for a transparent effect. Suggest some shadows on the dry Texture Paste and add accents where needed.

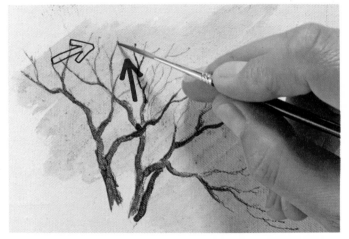

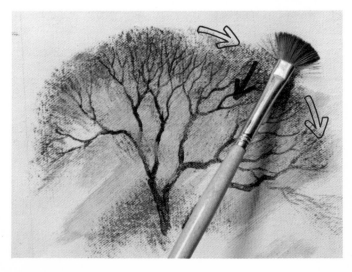

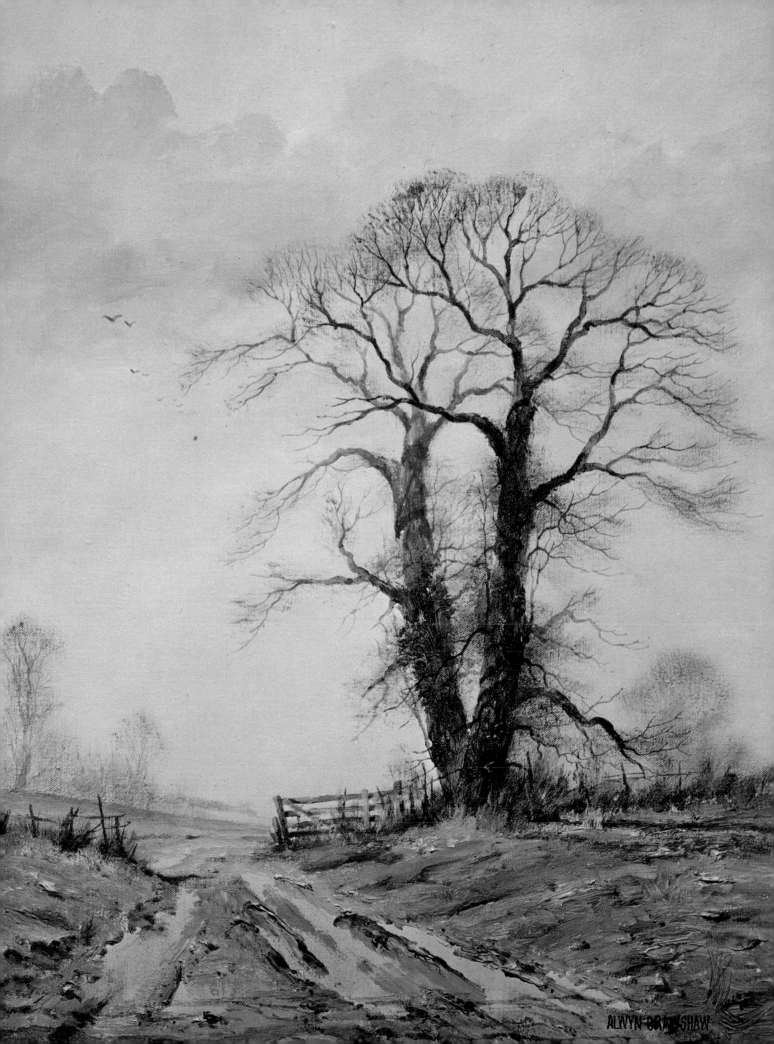

EXERCISE FOUR
SEASCAPE

The sea has always fascinated artists. You will find that most of the stalwart landscape artists have had their fair share of painting the sea. Two of Britain's finest landscape artists, Constable and Turner, couldn't resist the call of the sea and in the eighteenth and nineteenth centuries, it wasn't just a case of jumping into a car after Saturday lunch and reaching the sea in a couple of hours. I think the sea holds its fascination by seeming endless: you can go around the world by leaving from the shore where you are painting. It is vast and restless; it has extremes of mood that range from the blissful and romantic to the simply terrifying. Like the sky, the sea changes its colour all the time and, of course, it is never still. This must be observed from life. Sit on the beach and watch wave after wave coming in and breaking on the shore. It is very valuable to learn how a wave is formed and how it breaks. Then try sketching with a 3B pencil, concentrating on the overall form of the wave. You can't draw the same wave, of course – it's only there for seconds – but there's another and another and another. You have to get a sort of retained image to carry on to the next wave, and that further image on to the next, and so on. Then you can have a go at painting from life. Remember that the horizon line must always be level otherwise the sea will appear to be falling off the canvas. If necessary, draw the horizon line with a ruler. The sky must belong to the sea in colour and tone. Generally speaking, use the same colours for both. To give more interest in composition and colour to a seascape we have cliffs, beaches, rocks and boats. Cliffs and headland give distance and perspective. Beaches and rocks give us the opportunity to paint crashing waves with spray and foam flying everywhere. In the picture prepared for the exercise I have painted rocks because they are a good subject for acrylics.

First stage Draw the horizontal line with an HB pencil. Use a ruler to get it horizontal on the canvas. Then draw the rocks and waves. The bottom of the rocks is formed by the sea washing around them; therefore, it will follow the movement of the water and in most cases it will be level. Mix Ultramarine, Crimson and White for the top of the sky, add Cadmium Yellow with Crimson for the lighter clouds. Make this colour stronger (not as much White) on the right of the big rock. Paint this sky with a size No. 12 nylon brush and use Gel Retarder to paint wet on wet.

Second stage Paint the sea from the horizon to the big wave and rock. Use your size No. 4 nylon brush, mixing Ultramarine, Crimson, Bright Green and White. To the right of the rock add some more White with a touch of Cadmium Yellow as little highlights where the sun is coming through and catching the breaking waves. Under the top of the large breaking wave paint very thin (watery) Ultramarine and Bright Green. This will give the transparent colour of the wave where it is very thin. Now paint the shadow under the wave: this is the darker colour. The lighter colour is the foam that is running up the wave. Here, it is in shadow. The darker areas were achieved with Ultramarine, Crimson, Bright Green and a little White. The light foam was painted leaving dark areas and following the contour of the wave. Paint the side of the rock with Burnt Umber and Bright Green. Now, add much more White to the same wave colour and paint the rest of the wave – do not add too much White at this stage, leave some brightness up your sleeve. Lastly, paint the water breaking over the big rock. Keep this in shadow. Start at

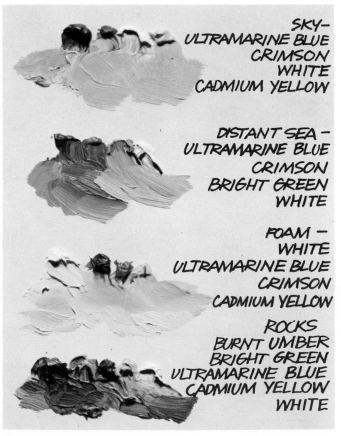

SKY-
ULTRAMARINE BLUE
CRIMSON
WHITE
CADMIUM YELLOW

DISTANT SEA –
ULTRAMARINE BLUE
CRIMSON
BRIGHT GREEN
WHITE

FOAM –
WHITE
ULTRAMARINE BLUE
CRIMSON
CADMIUM YELLOW

ROCKS
BURNT UMBER
BRIGHT GREEN
ULTRAMARINE BLUE
CADMIUM YELLOW
WHITE

First stage

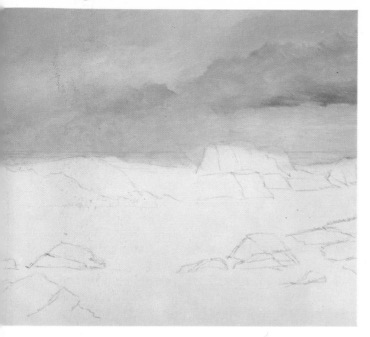

Second stage

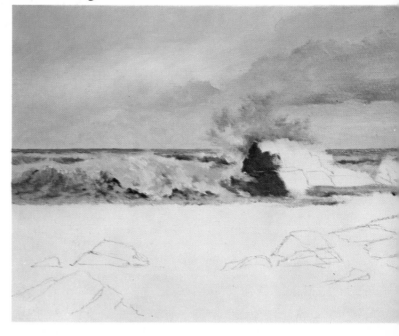

the rock and work your brush up and away. Let the brush – and yourself – feel like spray bouncing off a rock, get excited about it and you will find the result will be worthwhile. Experiment on a piece of paper if you like.

Third stage All you have to do in this stage is paint the rest of the sea. This is treated as underpainting because finally, it will have foam added over it. The rocks have been left unpainted at this stage, as all the sides except the bottom of the rocks appear in front of the water: it is easier, therefore, to paint them when the majority of the sea is finished so that they will have a clean edge against the sea. Using your size No. 8 nylon brush, mix Ultramarine, Crimson, Bright Green and White and paint the sea, starting from underneath the large wave and working across and down the canvas. Keep the brush strokes horizontal to keep the water level. As you come nearer the foreground let your brush strokes loosen up, add lighter and darker tones and your brush will form movement in the water. Don't be too critical of yourself; remember, a lot of this area will be covered in the next stage.

Finished stage Now to paint the foam on the water. Use a size No. 4 nylon brush with White, Coeruleum, Crimson and Cadmium Yellow. Work the brush horizontally in short strokes, changing the tone and colour (very subtly) all the time. You will be working on this part of the sea until the picture is finished. For the finishing touches on this foam use sable brushes to enable you to paint the finer modelling. Next, work on the big, breaking wave: use your size No. 8 nylon brush loaded with White plus a little Cadmium Yellow and Crimson. Put the brush on the edge of the rock and then push it up and away to get the spray effect. If it

Third stage

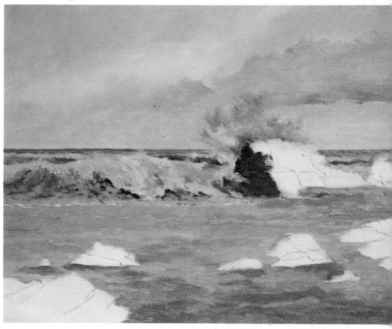

doesn't go right the first time, paint it dark again and have another go; or just practise on a piece of paper as you did in the second stage. Now retouch the big rock, just up to the wave and give it a clean edge. This part of the painting contains the darkest and lightest areas together, which produce a very sharp contrast. With the same brush and colour, paint some flying spume on the top of the large wave. Now dry the brush out and with a dry brush technique, using White and Ultramarine, work over the big rock and the bottom of the large wave by the rock; this will fuzz up the area around the rock and breaking wave, giving a feeling of misty spray. For the rocks you will need Texture Paste, Burnt Umber, Bright Green, Ultramarine, Cadmium Yellow and White. Use a size No. 8 nylon brush, don't mix the paint too much on the palette, let the mixing occur on the rocks. The Texture Paste and paint will thus make streaks of colour following the direction of your brush strokes and you will find that the rocks' contours are formed reasonably well, as long as your brush is worked in the direction of the rock surfaces. When this is nearly dry, add shadow to the dark side by dragging darker rock colour on to the rocks. You will find that it will drag up some of the existing paint in places: this again helps to show form and ruggedness. When the rocks are completely dry, with a dry brush add more colour – light and dark – to give even more texture. Finally, with a sable brush, pick out some shapes with dark or light colour. This is where you finish the large sea (foam) area. Work on this again, now that you have the tone of the rocks painted in and go over all your important highlights with Standard Formula White.

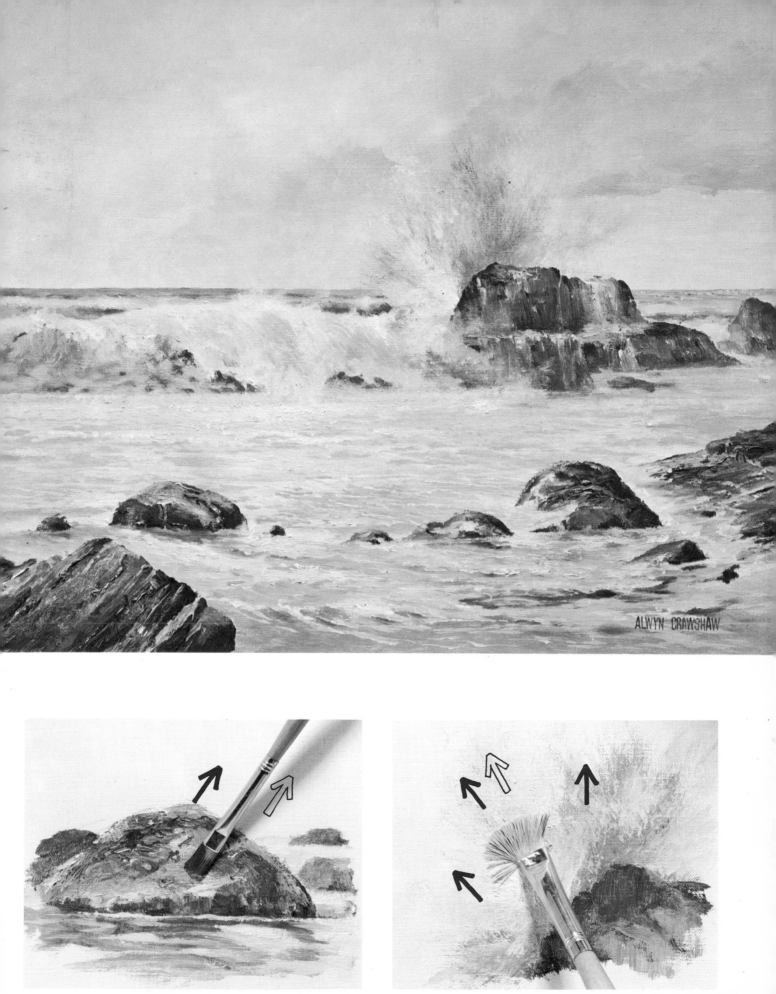

ALWYN CRAWSHAW

In some parts of the world, snow is never seen. But, for those who experience it even for only short periods, it has a fascination all of its own. The stillness and quietness of a snowy landscape can be unbelievable. The clear rivers of the spring and summer turn to brown and the trees stand out in sharp silhouette. One of the problems with painting snow is obvious: you can't take the family out for a picnic in six centimetres of snow nor can you sit on the ground to paint. Above all, it would be very cold. If you are going to paint out-of-doors, then you must be able to accept and endure nature's conditions. Always put on more clothing than you think you need. Put your sketch book in a polythene bag so that if you drop it in the snow, it will stay dry. I once dropped mine in a pond – without polythene! The most important rule I can suggest, when painting snow, is never to use just White for any of it. It is only white in its purest form – just fallen – and even then, it reflects light and colour from all around. So even the whitest snow should have some colour. Add a little blue to cool the white paint or a little red or yellow to warm it up. Never be afraid

to make snow dark in shadow areas. It can be as dark, in comparison to its surroundings, as a shadow in a non-snow landscape. The way to paint snow is to paint it in a low key: if we take our darkest shadow as number ten and our brightest snow as number one, with a natural gradation of tone in between, you should paint your snow in the range from eight to three. This will leave enough reserve up your sleeve to add darker shadows and brighter highlights.

First stage Use an HB pencil to draw the landscape, starting with the horizon. Next, draw the edge of the field with the two main trees on it, the other trees and the river banks. For the sky use Coeruleum, Crimson and White mixed with Gel Retarder. Half-way down the sky mix Cadmium Yellow, Crimson and White and paint back up into the wet 'blue' sky. Then paint down to the horizon, adding more Crimson as you go. This will give that lovely, luminous-sky effect.

Second stage With Coeruleum, Crimson, Cadmium Yellow and White, using a dry brush technique, paint the distant trees; then, with the same colours but much more White, paint the field underneath with a size No. 4 nylon brush. Paint the house with the same brush, the chimneys with your small sable brush. Put the highlight on the left of the house where the sun hits it. As in the landscape exercise, use a dry brush to paint the middle-distance trees and the hedge. Since the time is late afternoon, there is a warm glow in the sky and this should be reflected in the trees where the sun touches them: use more Crimson and Cadmium Yellow. Next, paint the snow on the lower field in the same way as the first one but make it very dark under the left-hand trees as this is in shadow. Next, paint the two main trees with Standard Formula colours Raw Umber, Burnt Umber, Bright Green, Ultramarine and Crimson.

Third stage Start by painting the feathery branches on both trees, using your size No. 8 nylon brush in a dry brush technique. Mix Cadmium Yellow, Crimson, Raw Umber and Ultramarine. Next, paint the hedge, using your size No. 4 nylon brush with Cadmium Yellow, Crimson and Ultramarine; use a dry brush and paint upwards. Now the water. This was painted as watercolour, i.e. using your size No. 8 nylon brush loaded with water and paint. You will find the paint runs down the canvas, which is how it should be. Use the brush flat on and run it down the canvas, starting each stroke at the top and at the side of the previous one. You will find the brush strokes will merge, giving a watery appearance. Use Burnt Umber, Crimson and Ultramarine.

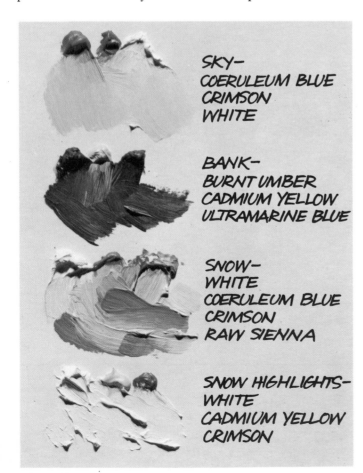

SKY–
COERULEUM BLUE
CRIMSON
WHITE

BANK–
BURNT UMBER
CADMIUM YELLOW
ULTRAMARINE BLUE

SNOW–
WHITE
COERULEUM BLUE
CRIMSON
RAW SIENNA

SNOW HIGHLIGHTS–
WHITE
CADMIUM YELLOW
CRIMSON

First stage

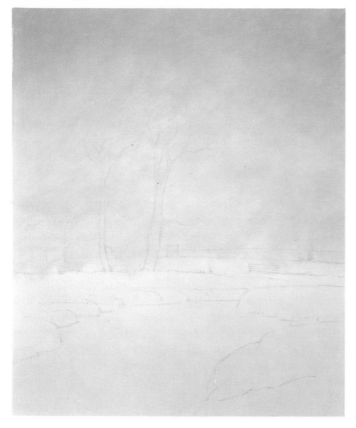

Second stage

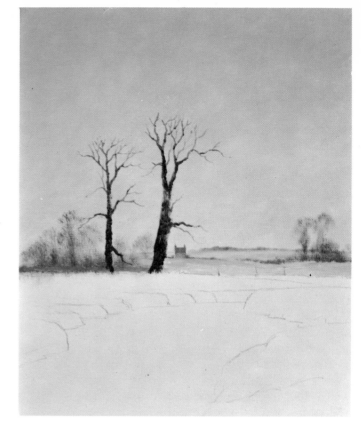

When the wash is absolutely dry, apply another over the top. If you look at the stage three illustration, you will see where my second wash came over the first one, which appears lighter. When the second wash is nearly dry, paint the reflections of the trees and bank. Use your size No. 4 nylon brush and start under the bank, bringing the brush down. You will find the paint mixes slightly with the second wash, giving a soft edge. Don't try to put all the branches in. Then, with horizontal strokes, paint the reflections under the river bank; keep your paint very watery.

Finished stage Paint the bank on both sides of the river: use your size No. 4 nylon brush and mix Burnt Umber, Cadmium Yellow and Ultramarine. The white area now left is going to be snow. Remember: paint from eight to three on your tone chart. Start under the trees, using White, Coeruleum, Crimson and Raw Sienna. Break up the line of snow under the hedge and change the tones and colours of the snow as you go, working down to the river bank. Drag the brush over the bank and into the painted bank areas. Now paint the trunks of the left-hand, middle-distance trees with your size No. 2 sable brush; use the paint thinly, working from the bottom of the trees upwards. With the same brush paint the small branches of the large trees, working downwards; for the left-hand one use warm colours as the sun is catching it. Notice the two small branches that have broken off and are in the hedge under the tree. Now you can finish the reflections in the water, using Burnt Umber, Ultramarine and Crimson with your

Third stage

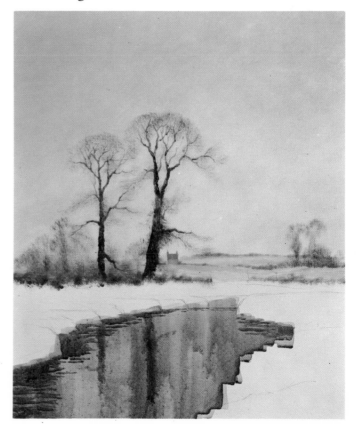

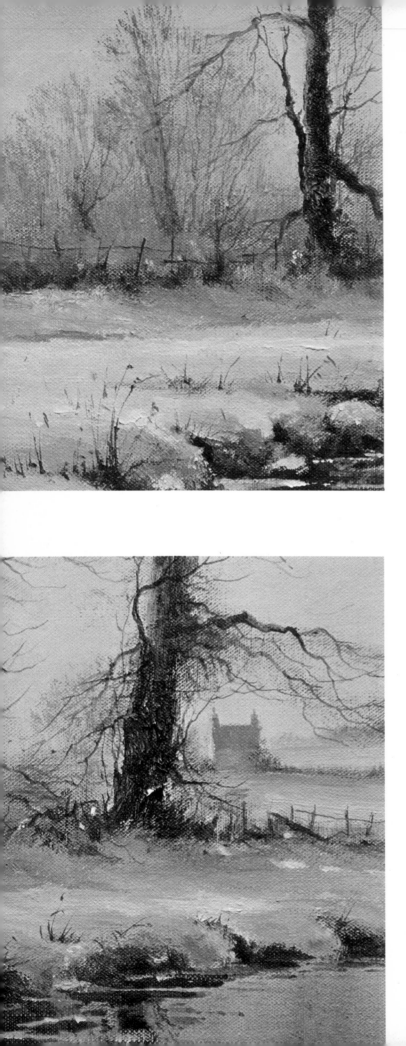

Finished stage

size No. 5 sable brush; paint the reflections watery. You will have to repeat the wash over the area a few times as this will help to express the movement of water over the reflections. When this is dry, paint the highlights with White, Cadmium Yellow and a touch of Coeruleum (slightly watery). Remember to keep your brush strokes horizontal. With your size No. 4 nylon brush mix a snow shadow colour from Coeruleum, Crimson, Raw Sienna and White. Paint the shadows on the left bank and run the paint slightly over the bank colour. You now have to bring the snow to life by highlighting it. Mix Standard Formula White, Cadmium Yellow and Crimson, use your size No. 4 nylon brush (very clean) and drag in a dry brush technique over the sunlit areas. If you have painted the snow in the right low key, you will be surprised how white the highlights appear and how the snow seems to sparkle. Next, paint the gate and the fence, using your sable brush with Raw Umber, Bright Green and White. Finally, with your size No. 2 sable brush, paint in the winter grass and plants that show through the snow; they will add depth and perspective. Start your brush stroke at the bottom and work up and off the canvas. These must be confident strokes or they will not look real. Practise on paper and get used to the brush stroke. Finish by adding your light and dark accents.

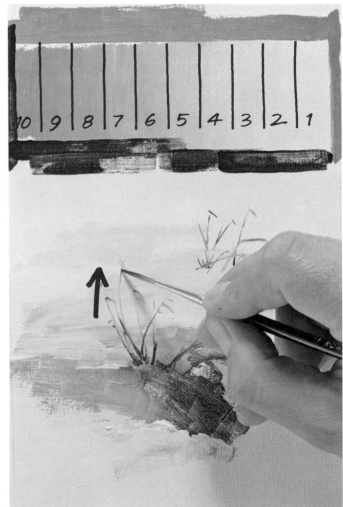

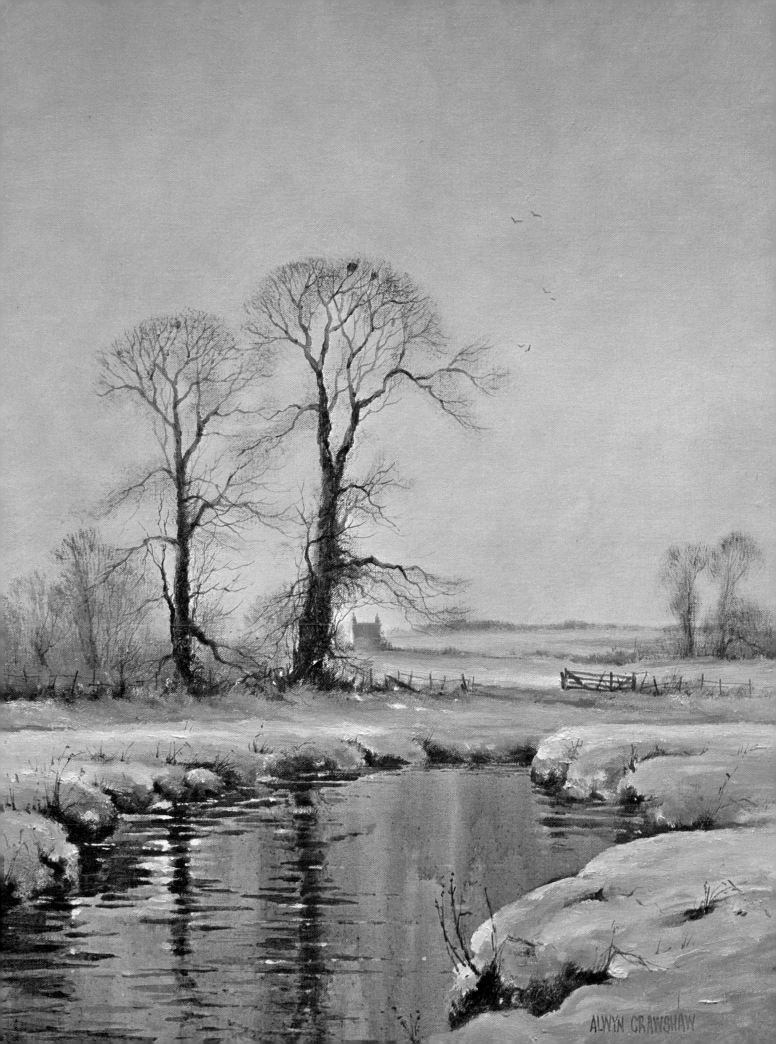

ALWYN CRAWSHAW

EXERCISE SIX
BOATS

We are back to the pull of the sea again. After all, boats are found on the sea and, therefore, the emotions we feel when painting boats are very similar to those we feel for the sea. However, I believe there is one difference. Boats make us feel more intimate with the sea; they reassure us about life on the sea by filling the emptiness of a vast expanse of water. In this painting of a Brittany harbour, your next exercise, we experience the intimacy of the scene: the boats give us a feeling of activity, while a friendly calm is conveyed by the very still, harbour water. More knowledge of drawing is needed to paint boats than to paint a landscape. For instance, if a branch of a tree you are copying is too low, it will still look fine in your painting but if a mast of a boat is leaning to one side, then the painting looks obviously wrong. A few days spent sketching all the bric-a-brac, natural and unnatural, of a small harbour – from an old wreck sticking out of a mud flat like the backbone of a great fish, down to an old piece of chain, all rusty and abandoned – would give you tremendous knowledge and make you familiar with boats and their surroundings.

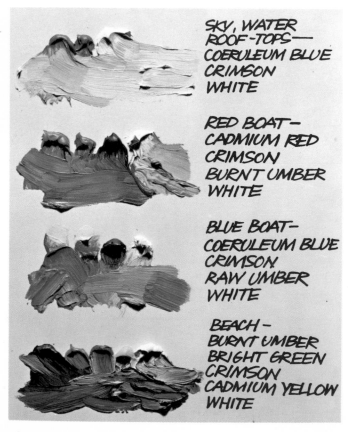

SKY, WATER
ROOF-TOPS—
COERULEUM BLUE
CRIMSON
WHITE

RED BOAT—
CADMIUM RED
CRIMSON
BURNT UMBER
WHITE

BLUE BOAT—
COERULEUM BLUE
CRIMSON
RAW UMBER
WHITE

BEACH —
BURNT UMBER
BRIGHT GREEN
CRIMSON
CADMIUM YELLOW
WHITE

First stage I drew this harbour scene from a sketch and, therefore, had plenty of time to correct the drawing and make a careful study on the canvas in the studio. Had I painted this outside, the drawing would have been looser and I would have corrected it as I painted. First, draw the harbour wall; make sure the bottom is horizontal on the canvas. Next, draw the hill, a few of the main buildings in the distance and the middle-distance boats that have definite shapes. The other boats, which make this a bustling harbour, will be ad-libbed when you are painting. Finally, draw the main boat and the little one on the beach. The sky and water are exactly the same colour at this first stage. Using a size No. 12 nylon brush, mix Coeruleum, Crimson and White. Paint from the top, well over the hill and buildings, adding more Crimson as the sky disappears behind the hill. Using the same brush and paint, continue over the water to the beach.

Second stage Look at the picture: apart from the hill behind the harbour, which had Bright Green added to the previous colours, all the rest of the buildings in this stage were painted in Coeruleum, Crimson and White for the roof tops, adding Raw Sienna, Cadmium Yellow, Raw Umber and White for the walls. Again, it appears that a lot of colours were used but if you look closely, the real colour is Coeruleum for the roof tops and Raw Sienna for the rest. The other colours are there to be added sparingly, as I have said before. But remember, it is this *variation of colour* and tone that gives a painting life. Use your size No. 4 nylon brush, paint in the hill, then the roof tops and then the lower parts. Don't try to make every building just like mine, it would be impossible. It is an impression of buildings you want to achieve. They are in the distance, so paint them in low key. Put no more detail than the windows and shutters (only suggested) with a sable brush. On the right of the picture let the buildings merge even more to give distance. Paint the background inside the cabin windows when painting the buildings. For the main fishing boat use Cadmium Red, Burnt Umber, Crimson and White. Only add Crimson to the shadow areas and White to the light parts. Start with the cabin – leaving the window frames – then the hull. In my original, a size No. 4 nylon brush was almost plank size, which was ideal because you must paint the hull plank by plank, starting from the top. At the stern of the boat add White where the light catches the wood. Paint over the red with White, Coeruleum and Crimson in the spots where the paint has worn off the boat. Then add Cadmium Yellow to the white in the cabin framework.

First stage

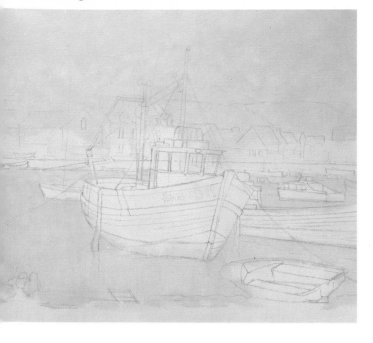

Second stage

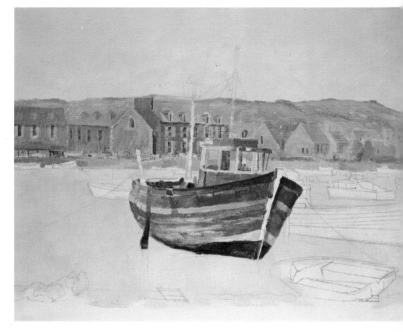

Third stage Use the colours that you adopted for the buildings and a very wet size No. 8 nylon brush to put in the reflections. Start underneath the harbour wall, using the brush flat, and work down, changing the colours slightly as you paint along the canvas. Paint over the drawing of boats. While the paint is still wet put in the window reflection. Now paint the boats: the secret is to give an impression of a harbour busy with small craft and to keep them in the distance so as not to overpower our fishing boat in the foreground. For your white paint now use Standard Formula colour to mix with the colours for the boats. Use your size No. 4 nylon brush and toned-down colours; with light colours paint oblong shapes to represent boats in the distance, then add some dark areas (cabins, ends of boats, etc.). Put in some masts with your small sable brush, some light and some dark. If you look closely at stage three illustration, you will see that the only real boats are the cabin cruiser on the right and the bows of the yacht to the left of the red boat. These you have to paint carefully as it is these that give the eye the impression that all the shapes and masts behind are boats. A little more detail will be put in at the final stage. Now add the old boat on the right. Use your size No. 4 nylon brush and paint it in planks as you did the red boat, using Coeruleum, Crimson, Raw Umber and White. When dry, drag over some darker paint in dry brush to give an ageing look. Finally, paint the front of the bows on the red boat.

Third stage

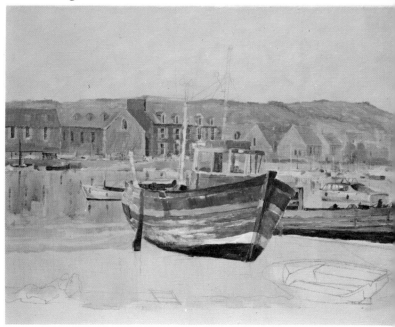

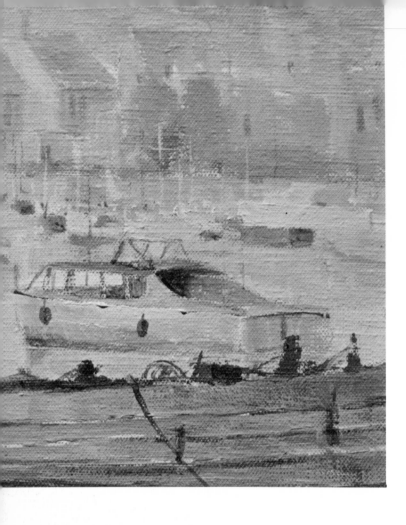

Finished stage There are a lot of small details to be finished and it would not be possible for me to describe all the necessary passages. The important thing is to paint them with the right brush and in the correct order. Read this section through carefully before continuing and you will get the feel of what there is to do. Using a size No. 4 nylon brush, paint the reflections of the red boat and the old one. Use as watercolour a mix of Coeruleum, Crimson and Burnt Umber, and as you wash this down to the beach add Cadmium Red. Put at least two washes on, then paint a very dark shadow under the boats with Ultramarine, Crimson and Burnt Umber; spread this up on to boats to merge boats and water. Next, work the masts with your size No. 5 sable brush; then, with the same sable brush, line in the red boat – for instance, the edges of planks and the shadow side of the windows; add a bit more dark at the same time to the cabin windows. With your size No. 2 sable brush, paint the lobster pot on the cabin with a dark colour, then with the same brush add lighter lines to give it shape – Raw Sienna and White. Put a wash shadow to the right of the red boat bows; use Ultramarine and Crimson. Put the mast on the yacht and darken the hull next to the red boat. With your sable brush add the mast reflections. With the size No. 2 sable brush, paint the rigging lines: keep the paint watery. Now, with the size No. 4 nylon brush paint the blue boat, using Coeruleum, Crimson, Raw Umber and White, adding Ultramarine for the darkest shadows. Using the same brush, mix Burnt Umber, Bright Green, Crimson, Cadmium Yellow and White, add Texture Paste and paint the beach. When it is dry add some shadows and the bits of old lobster pots on the left with your size No. 3 sable brush. Put a dark shadow under the blue boat and on the beach. Using the paint thin, darken the old boat with Coeruleum, Crimson and Raw Umber. Add some Standard Formula Cadmium Red and White to the red boat to give some weathering. As with the other exercises, leave your painting at this stage, come back later with a fresh eye and then make your final statements by adding dark and light accents. This painting will take a long time if you put all the details in. Have patience, it will all come right in the end, although when you are working this seems a long way off.

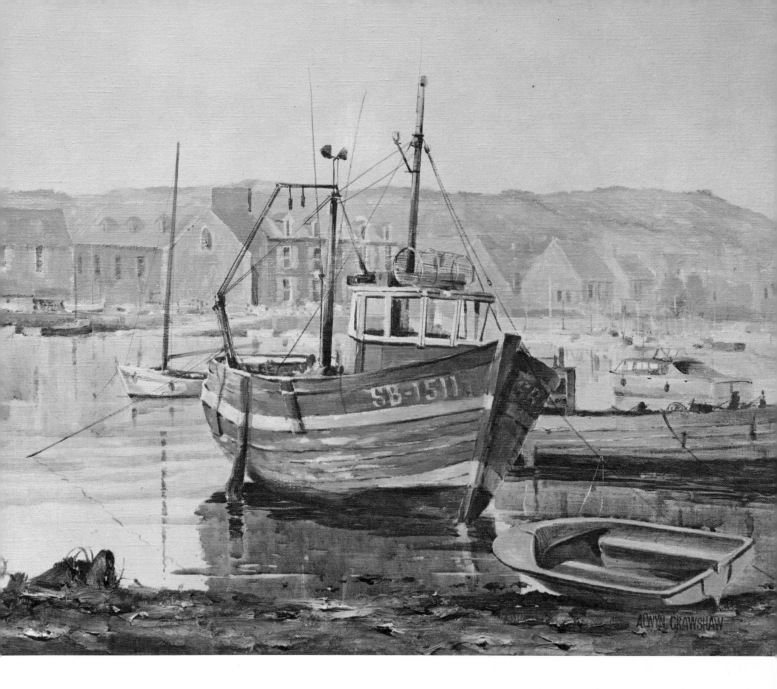

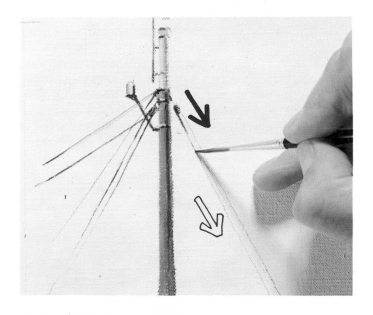

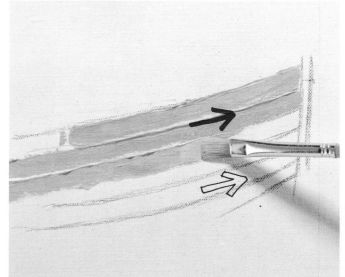

EXERCISE SEVEN
PORTRAIT

For the student, portrait painting offers many of the advantages of still life and flower painting. You can dictate lighting, colour scheme and mood. The painting of a portrait does not depend on the weather but only on your model's availability. However, remember that you always have one model with you – yourself; all you need is a mirror. Try some sketches first with a 3B pencil. When you are sitting at home in the evening, sketch members of the family watching television. Study the light and shade that form the broad areas of the face; check the relative position of the features; look for any distinguishing detail and slightly exaggerate it. An exercise I once tried, to train myself to pick out the distinguishing features, was to sketch from the television. This gives you no more than about ten to fifteen seconds and fifteen to thirty pencil lines with which to try to get a broad likeness. It's also very good practice if you want to paint children, who seldom keep still. You can paint portraits without necessarily getting a true, photographic likeness; this can come through as an impression – a feeling; if you want detail, build up to it gradually through practice and careful observation.

First stage Draw the main features of the face. The spectacles are as important as the nose or mouth. Draw the cap next and then the jacket. For the background, mix Cadmium Yellow, Ultramarine, Crimson and White. Paint the skin tones on the face with Cadmium Yellow, Crimson and Burnt Umber, no White. Paint them transparently, using plenty of water.

Second stage Using a size No. 4 nylon brush, mix Raw Sienna, Cadmium Red, Cadmium Yellow and White, and paint the light areas of the face, going into the dark areas already painted. Now mix Raw Sienna, Ultramarine, Raw Umber, Cadmium Red, Crimson and just a little White. Paint over the dark areas again, modelling the features as you go; blend into the light tones. Now, replace Ultramarine with Coeruleum and paint the dark accents in the shadow area. With your size No. 5 Series 43 sable brush mould the eyes, but remember they are in shadow and the whites should be toned down: use Coeruleum, Crimson, Cadmium Yellow and White; you will also need some highlights to help with the shape. Do this at this stage but keep the lighter tones in the shadow area down in key. Put the dark accents on the nose and lips. Add a little pure Cadmium Red on the lower lip and give it the highlight it needs. You will notice that the spectacles can still be made out under the paint: this is necessary because it helps you with the shape of the face. Now mix Cadmium Red and Crimson with glaze medium (wash your size No. 4 nylon brush thoroughly before you start) and glaze over all the face; this will give it an all-over appearance and will help to add luminosity and hold it all together. The more you glaze, the more real your skin tones will appear. Add some more whitish blue on the eyes where you went over the white with your glaze. With a mixture of Coeruleum, Crimson, Raw Umber and White paint the beard and hair, using your size No. 4 nylon brush. Lastly, put in the light skin tone on the right of the face, on the forehead and cheek.

Third stage Now to paint the cap and jacket: use broad brush strokes, changing the tones as you paint: it will create a cloth-like look. Any detail you want to put in will

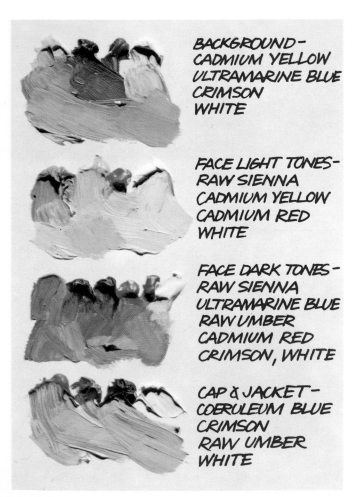

BACKGROUND –
CADMIUM YELLOW
ULTRAMARINE BLUE
CRIMSON
WHITE

FACE LIGHT TONES –
RAW SIENNA
CADMIUM YELLOW
CADMIUM RED
WHITE

FACE DARK TONES –
RAW SIENNA
ULTRAMARINE BLUE
RAW UMBER
CADMIUM RED
CRIMSON, WHITE

CAP & JACKET –
COERULEUM BLUE
CRIMSON
RAW UMBER
WHITE

First stage

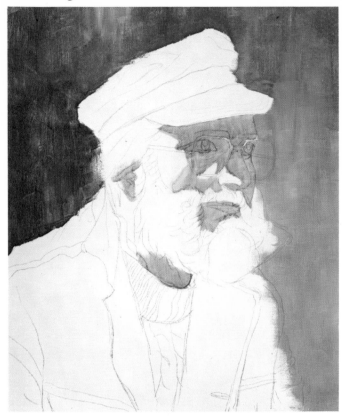

Second stage

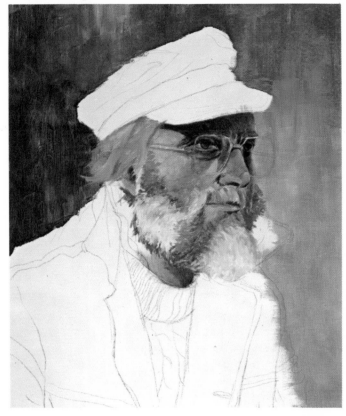

be done in the final stage. Mix Coeruleum, Crimson, Raw Umber and White for the colour. You will find that the light areas are almost all white with just a little blue added. Start with the cap and let the brush stroke by floppy; use a size No. 4 nylon brush. The only detail to put in is the band between the peak and top of the cap; with a size No. 5 sable brush paint the lines round this band with dark and light tones to suggest the stitching; it also helps to give shape to the hat. Now the jacket: use a size No. 8 nylon brush; the only details you need are the seams and the lapels. Accentuate these, when you have painted all the jacket, with a size No. 5 sable brush, using light and dark tones.

Finished stage Start by painting the red collar. For the shadow area use Cadmium Red, Raw Umber and Ultramarine. The red catching the light is pure Cadmium Red. Next, paint the jumper using your size No. 4 nylon brush and a mix of White, Coeruleum, Crimson and Cadmium Yellow. With the edge of the same brush put in the modelling of the neck ribbing; keep the highlight on the top edge of the neck to show the thickness of the jumper. The beard is made up of thousands of springy hairs: to create this effect on canvas we have to place a few of them very strategically. Use your size No. 3 sable brush, Series 43, paint from where the beard starts on the cheek and work down with short, definite brush strokes. Use three tones: very dark (Ultramarine, Crimson and Cadmium Yellow) medium (same colours plus White) and light (nearly all White). Use

Third stage

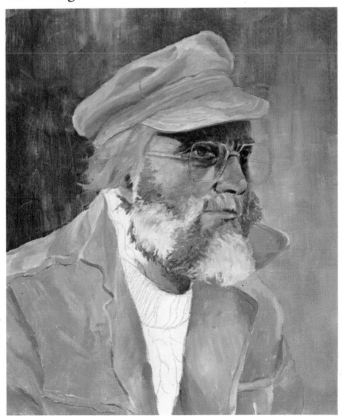

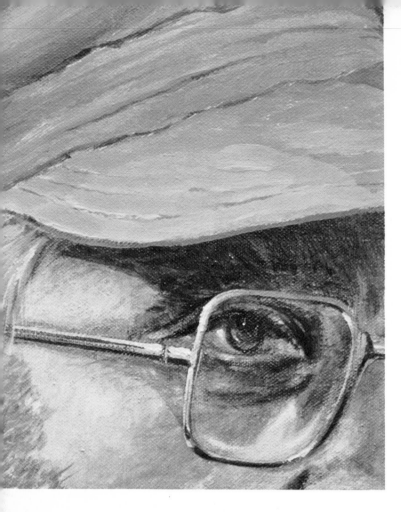

the brush with water to let the paint flow. Your wrist will ache after all those deft strokes but before you finally finish the beard, place some well thought-out, highlight hairs over dark areas, such as the neck shadow. The hair is entirely different, it is soft and long. Use your size No. 5 sable brush, add more Cadmium Yellow to the lighter tones you used for the beard and bring the brush down from the cap in long, smooth strokes, giving the impression of hair rather than painting single hairs. Paint the small shadow under the hat, following the contours of the hair. Paint the glasses with a medium tone all over the frames, using a size No. 3 sable brush, Series 43. Then add a darker tone and finally, your light tone. Add your highlights next, using some flesh colour in places as these reflect the face colour. With the same brush mix some White (watery) and paint the right-hand lense from the top downwards. This will give a shine to the glass. Do the same on the bottom of the other lens. Finally, as usual, look at the painting with a fresh eye and add those very important light and dark accents. Notice how the jacket has been kept unfussed to give the face more prominence.

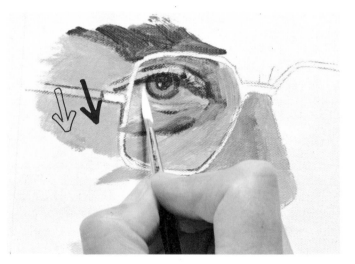

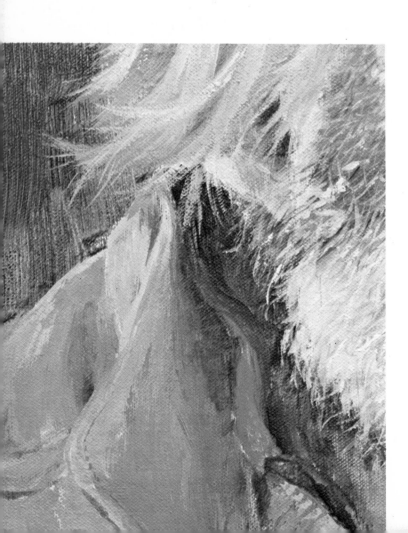

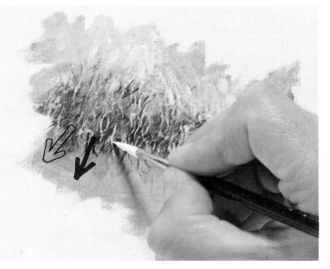

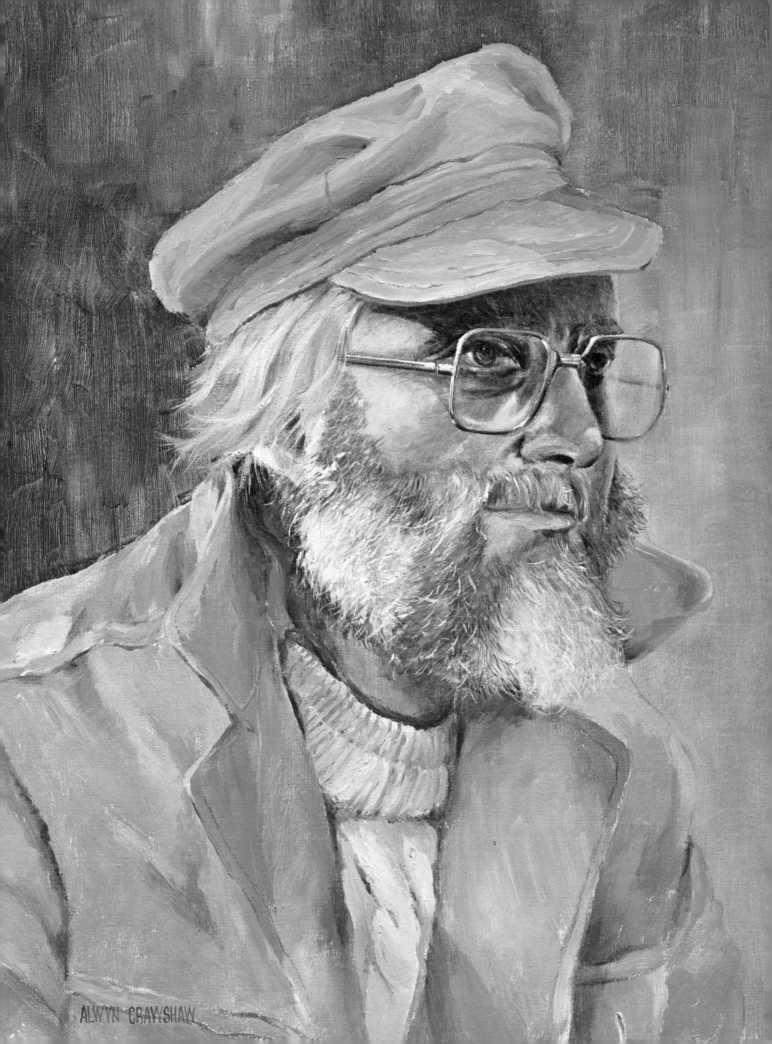

ALWYN CRAWSHAW

Now that the last exercise is finished, you should be familiar with acrylic colours, their consistency and versatility.

I have really enjoyed writing and painting for this book which has taken up most of my time over a period of six months. At first, it seemed a formidable task – as I sat confronted by sixty-four blank pages! But as I became involved and tried to imagine you, the reader, at my side, the work became easier and more fascinating each day.

If you have enjoyed working through the book and have learned something, then my endeavours are fully rewarded.

When I was asked to arrange the paintings for the photograph above, I was staggered at the amount of work that had accumulated for reproduction – I shudder to think how much painting you have gone through!

Keep painting and good luck.